ESSENTIAL MODERNISM

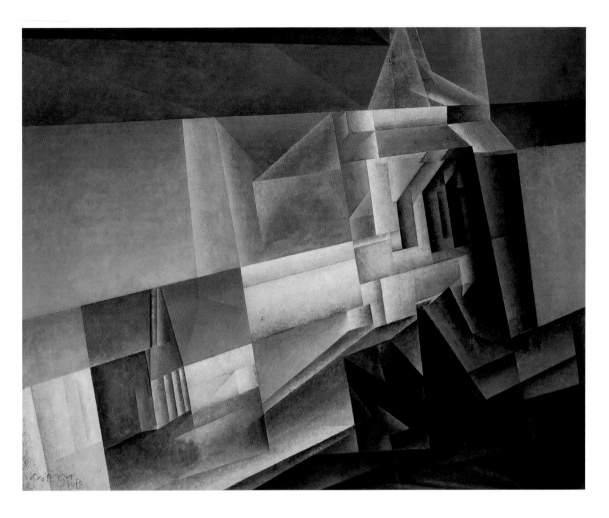

Lyonel Feininger
ZIRCHOW VII, 1918
Oil on canvas
National Gallery of Art, Washington, D.C.,
gift of Julia Feininger, 1966.3.1

The American-born Feininger painted this
work while living in Germany during World
War I. The church is presented in a style
that—with its structural unity, rhythmic
organization of planes of color, and
relationship between light and material—
owes much to Analytic Cubism.

ESSENTIAL MODERNISM

Philip Brookman, Paul Greenhalgh, Sarah Newman

CORCORAN
GALLERY OF ART · COLLEGE of ART + DESIGN

Produced by V&A Publications, 2007

V&A Publications
Victoria and Albert Museum
South Kensington
London SW7 2RL

in association with

Corcoran Gallery of Art
500 Seventeenth Street, NW
Washington, D.C. 20006
www.corcoran.org

Published on the occasion of the Corcoran Gallery
of Art's presentation of the exhibition
Modernism: Designing a New World 1914–1939
March 17–July 29, 2007
Exhibition originally conceived by and first shown at
the Victoria and Albert Museum, London, in 2006.

A catalogue record of this book is available from the
Library of Congress.

ISBN 0 88675 079 2

Every effort has been made to seek permission to
reproduce those images whose copyright does not
reside with the Corcoran Gallery of Art, and we are
grateful to the individuals and institutions who have
assisted in this task. Any omissions are entirely
unintentional, and the details should be addressed
to the Corcoran Gallery of Art.

Produced by V&A Publications
Designed by Janet James
Edited by Pete Clark
Project management by Geoff Barlow
Printed in Hong Kong by South Sea International Press Limited

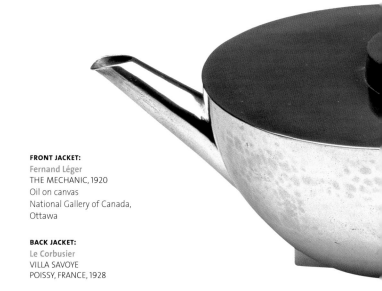

FRONT JACKET:
Fernand Léger
THE MECHANIC, 1920
Oil on canvas
National Gallery of Canada,
Ottawa

BACK JACKET:
Le Corbusier
VILLA SAVOYE
POISSY, FRANCE, 1928

CONTENTS

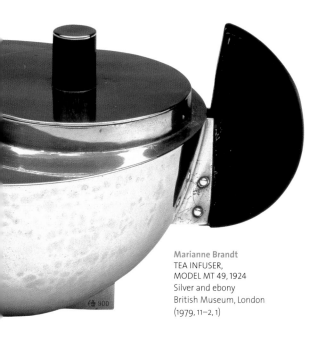

Marianne Brandt
TEA INFUSER,
MODEL MT 49, 1924
Silver and ebony
British Museum, London
(1979, 11–2, 1)

Acknowledgments

This book was produced to coincide with the exhibition *Modernism: Designing a New World 1914–1939*, which opened at the Corcoran Gallery of Art in March 2007. The authors would like to thank many people.

Pete Clark edited the manuscript; Katy Murnane and Courtney Ruch worked on the illustrations, text, and more. Elizabeth Parr and Nancy Swallow coordinated the many details of the exhibition and its installation; Catherine Armour designed it, and Rebecca Gentry managed its development and promotion. The team creating *Modernism: Designing a New World* at the Corcoran worked miracles: Antonio Alcalá, Caesar Chaves, John deWolf, Sarah Durkee, Cory Hixson, Chris Pelletier, Leslie Shaffer, and Ellen Tozer. Others at the Corcoran played important roles: Marisa Bourgoin, Steve Brown, Allison Chance, Christina DePaul, Dorothea Dietrich, David Dorsey, Elizabeth Emslander, Jocelyn File, Maria Habib, Dare Hartwell, Laura Harwin, Deborah Jones, Chris Leahy, Mike McCullough, Deborah Mueller, Andrea Romeo, Paul Roth, Kem Sawyer, Richard Selden, Beth Shepard, Janet Solinger, Susie Stockwell, Sian Sutcliffe, Mary Tinkler, Cynthia Williams, Jason Zimmerman, and Marjory Zimmerman.

The Board of Trustees of the Corcoran, led by Chairman Jeanne W. Ruesch, supported the project throughout: Ronald D. Abramson, Esq., Carolyn S. Alper, Sarah E. Chapoton, Paul I. Corddry, Laura P. Coughlin, Cherrie Wanner Doggett, Anne N. Edwards, Emanuel J. Friedman, Michael N. Harreld, Anne Barnett Hazel, John T. Hazel, Jr., Eleanor F. Hedden, Lelia G. Hendren, Harry F. Hopper III, Julie J. Jensen, Christopher Niemczewski, William A. Roberts, Helen C. Smith, and Ralph C. Taylor, Jr. Timothy Coughlin, Bernard Koteen, and Deane Shatz were instrumental in our efforts, as well.

Friends outside of the Corcoran gave freely of their time and made many things possible: Merrill Berman, Kerry Brougher, Elizabeth Broun, Stephen Daiter, Jim Frank, Jay Gates, Judy Greenberg, Eleanor Harvey, Barbara Haskell, Howard Greenberg, Mike Lee, Mark Leithauser, Russ Markhovsky, Jane Pavitt, Rusty Powell, Eliza Rathbone, Andrew Robeson, C. Raman Schlemmer, Elizabeth Siegel, Chris Stevens, Dodge Thompson, David Travis, Olga Viso, Christian Wolsdorff, Adam Weinberg, Jeffrey Weiss, Mitchell Wolfson, Jr., and Ghislaine Wood.

We would like to thank the many institutions and private collectors who lent to the exhibition and agreed to allow their works to be illustrated here. Finally, we are most grateful to our colleagues at the V&A in London who originated the exhibition: the curator of the exhibition, Christopher Wilk, assisted by Corinna Gardner and Jana Scholze, Director Mark Jones, Head of Exhibitions Linda Lloyd Jones, Head of Publications Mary Butler, and the staff of the Exhibitions, Publications, and Research Departments of the V&A. Thank you all.

Philip Brookman, *Director of Curatorial Affairs*
Paul Greenhalgh, *Director and President*
Sarah Newman, *Assistant Curator of Contemporary Art*

Director's Foreword

This book has been written to accompany the exhibition *Modernism: Designing a New World 1914–1939*, which first opened at the Victoria and Albert Museum in London in 2006. This enormous exhibition arrives here at a very important moment in our history.

The Corcoran Gallery of Art is one of the oldest art institutions in America. Following the pattern of a number of grand Victorian centers for the study and display of art, the Corcoran was configured both as a gallery and a college. The Corcoran essentially has five areas of permanent collection: historic American art, European art, photography and media arts, decorative art and sculpture, and contemporary art. As well as having some of the most beautiful spaces for the display of these collections, it is also a center for training, providing undergraduate and graduate programs in art, craft, design, art education, and the history of decorative and fine arts.

There is also an extensive continuing education program, research in art education, and an award-winning community outreach program.

In this way, thousands of Washingtonians study and make art as part of the Corcoran family.

This exhibition has arrived as we are planning our future. We are restoring our historic building; expanding our gallery and public spaces; building an additional campus for our students; further developing our academic programs; showcasing our extraordinary collections; staging spectacular exhibitions; and growing our community outreach programs to provide art education to citizens of all ages throughout our region.

The Corcoran was founded to forward the enjoyment and study of the visual arts in a young nation; in exactly the same way, we are committed to forwarding the cause of the arts in the new century.

The arts are life-enhancing. The Corcoran is premised on the idea that everyone can experience the arts, and everyone deserves to do so. *Modernism: Designing a New World* is one example of the Corcoran's commitment to this mission and to our community.

Paul Greenhalgh
Director and President

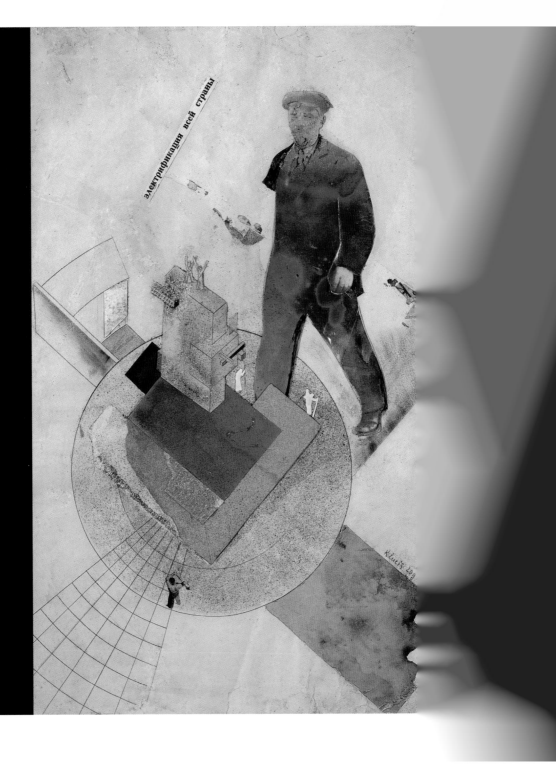

THE MODERN WORLD

Gustav Klutsis
ELECTRIFICATION OF THE
ENTIRE COUNTRY, 1920
Photomontage and
mixed media
Merrill C. Berman Collection

Never before have the conditions of life changed so swiftly and enormously as they have changed for mankind in the last fifty years. We have been carried along … [and] we are only now beginning to realize the force and strength of the storm of change that has come upon us.

H.G. Wells, who wrote this passage in 1933, knew that he was living in a time of absolute and unprecedented transformation. People's lifestyles were changing forever, and this filled the great author and futurist with both excitement and foreboding. He saw that, given the extraordinary new powers science had delivered, humanity might perfect the world or use these new capabilities to bring about total annihilation.

At this point, Wells was living in that nervous and frenetic time that fell between the grim bookends of two World Wars. Technologically, this was not an especially innovative period. The electric lightbulb, the automobile, the airplane, the skyscraper, the radio, and the telephone all predate World War I. It was a time of development and dispersal rather than invention; it was during the period between the two World Wars that these life-changing technologies became widespread.

It was also the time when architects, designers, and artists passionately committed themselves to the idea of a modern style. In some ways they were reacting to the unprecedented violence and destruction they had witnessed during World War I; and they were searching for ways to create a better world through art. Across the arts, both fine and applied, creative artists were striving to design things that would both reflect and influence the events and the environment of this particularly fraught period. And this is the period we most closely associate with the term Modernism.

Hans Ledwinka
TATRA T87 SALOON CAR, 1937
Silver-gray lacquered metal
Die Neue Sammlung—State Museum of Applied Arts and Design, Munich

Around 1930, the Czech company Tatra radically reconceived the design of the standard box-shaped automobile. Following several prototypes, the Tatra T87 premiered in 1937 as the first true streamlined production automobile. With its signature dorsal fin and aerodynamic design, it ran at speeds and efficiencies that rival contemporary cars.

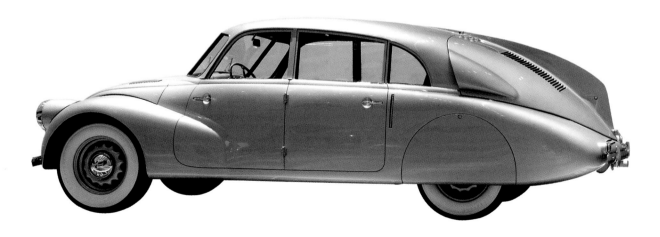

The Supreme Style The Modernist architects and designers practicing during the interwar years of 1914–1939 created a style and a set of technical approaches to the manufactured world that came to dominate the appearance of cities over much of the planet.

Arguably, this process continued throughout the entire century, and is still in progress. Modernism has been the most successful visual style in human history.

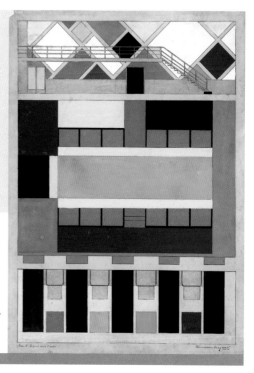

Theo van Doesburg
COLOR SCHEME OF FLOOR AND LONG WALLS OF CINEMA-DANCE HALL, probably 1928
Ink, gouache, and metallic gouache on paper
The Museum of Modern Art, New York, Gift of Lily Auchincloss, Celeste Bartos, and Marshall Cogann 1982 (391.1982)

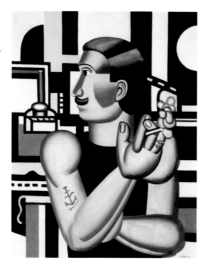

Fernand Léger
THE MECHANIC, 1920
Oil on canvas
National Gallery of Canada, Ottawa

With his noble profile and regal bearing, Léger's mechanic suggests a modern version of an Egyptian god. His bare tattooed arms, polished hair, and even the puffs of smoke emanating from his cigarette are composed of smooth geometries—echoing the parts of the machines with which he works. In form and function, *The Mechanic* embodies the ideal of industrial modernity.

Modernism in the arts was a response to the abrupt modernization of the world. Advances in technology and changes in social economics since the eighteenth century helped bring about radical changes in the way that most people lived. Political revolutions reshaped the social landscape of Europe and the Americas; and the Industrial Revolution, powered by coal, steam, and the burgeoning railroads, radically changed the way people worked. Meanwhile, adding to an international sense of revolution and dislocation during the nineteenth and early twentieth centuries, world populations exploded. Partly as a result of this, large numbers of people emigrated from Europe to the United States and Latin America.

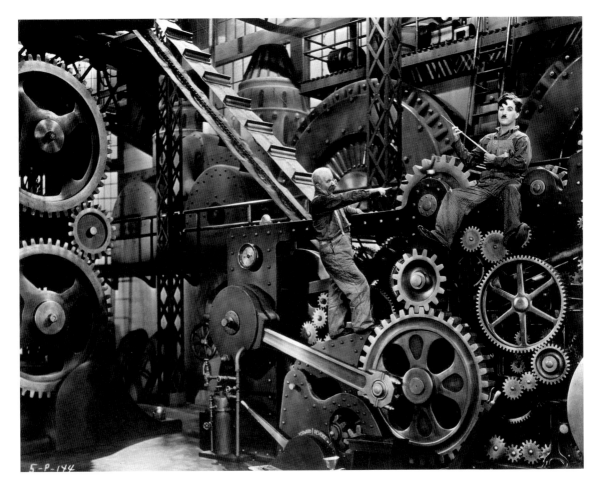

Charles Chaplin
MODERN TIMES, 1936
Film: 89 mins, sound, black and white
Produced by Charles Chaplin Productions and United Artists, USA
In his final silent film, Chaplin threw his Little Tramp into the
soulless world of modern factory work. Echoing the concerns
of the 1930s Great Depression in which it was made, *Modern
Times* addresses poverty, hunger, unemployment, and the
dehumanizing effects of the machine. The film's most
memorable sequences show Chaplin physically intertwined
with the factory itself: stretched around an enormous gear-
wheel, and being force-fed by a machine in order to speed up
production. Critics have pointed to Chaplin's despair at the
mechanization of his own beloved art of filmmaking as one of
the movie's motivating impulses.

In the opening decades of the twentieth century,
modernization accelerated because of increased
demand for emerging technologies—notably
electricity, improved medicines, the telephone, the
automobile, the airplane, and the cinema. Fast
international travel also meant that ideas could
spread more quickly.

Indeed, the world itself was moving faster
than ever before. The future became an urgent,
demanding reality that people of all social classes
were pressured to contemplate—and to join.

Lester T. Beall
LIGHT, 1937
Silkscreen on paper
V&A: E.265–2005

Beall's visually dramatic posters
for the Rural Electrification
Administration were designed
to promote Franklin Delano
Roosevelt's mission to provide
electricity and jobs to America's
rural communities through
governmental intervention. In this
poster—one in a series advocating
the benefits of such technologies
as radio, plumbing, and washing
machines—rays of electric light
emanate from a large lightbulb and
illuminate the interior of a small
farmhouse. Because much of the
intended audience for these
posters had limited reading ability,
the message was one of bold,
graphic simplicity.

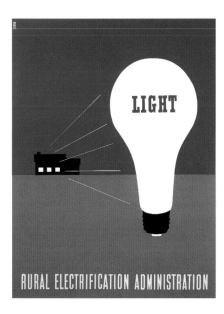

Hans Finsler
OSRAM LIGHT BULBS, c. 1928
Gelatin silver print
Corcoran Gallery of Art,
Washington, D.C., Museum
Purchase, Brenda and
Robert Edelson Collection,
1998.35

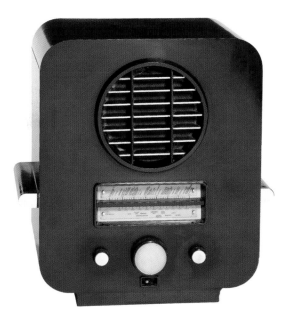

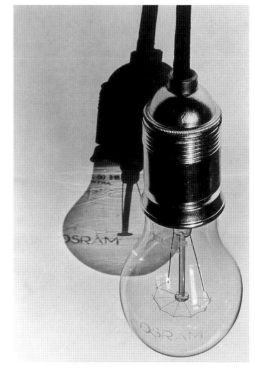

Serge Chermayeff
EKCO MODEL EC 74 RADIO, 1933
Bakelite case
V&A: CIRC.12–1977

J.J.P. Oud
DESIGN FOR KIEFHOEK WORKERS' HOUSING, ROTTERDAM
HILLEDIJK, 1926–1930
Color on photograph mounted on board
Nederlands Architectuur Instituut, Rotterdam (PH 1697)

Oud's great interest and work were in the design of mass housing. At age twenty-eight he was appointed municipal architect of Rotterdam, where he supervised a number of projects. Although spare and minimal, the Kiefhoek house plans were designed for large families and were built on a very tight budget. They were subsequently lauded for their attention to the practical realities of working-class living.

The most dramatic, seminal modern art forms were created in the first half of the twentieth century. Specifically, it was during the interwar years of 1914–1939 that spectacularly successful templates were created for many of the buildings, fixtures, and fittings that still typify the modern world. In effect, the invention and consolidation of an international modern style provided the foundation for the development of Modernism.

This book describes exactly what Modernism was; how it affected architecture and design; and where, and in which countries, it was manifested most powerfully.

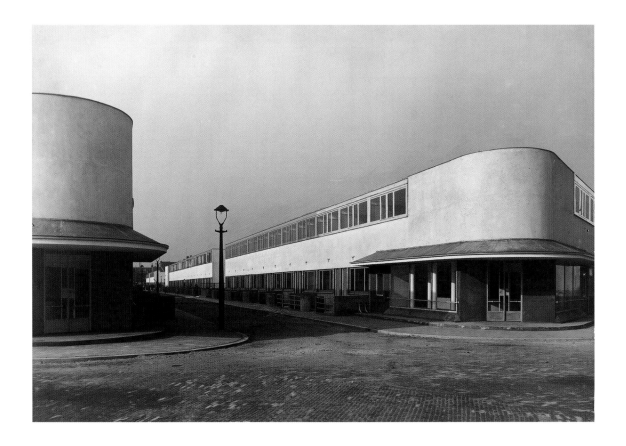

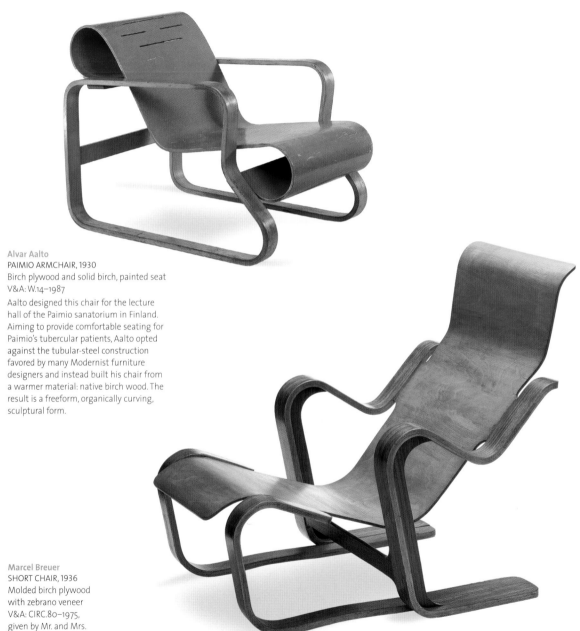

Alvar Aalto
PAIMIO ARMCHAIR, 1930
Birch plywood and solid birch, painted seat
V&A: W.14–1987
Aalto designed this chair for the lecture
hall of the Paimio sanatorium in Finland.
Aiming to provide comfortable seating for
Paimio's tubercular patients, Aalto opted
against the tubular-steel construction
favored by many Modernist furniture
designers and instead built his chair from
a warmer material: native birch wood. The
result is a freeform, organically curving,
sculptural form.

Marcel Breuer
SHORT CHAIR, 1936
Molded birch plywood
with zebrano veneer
V&A: CIRC.80–1975,
given by Mr. and Mrs.
Dennis Young

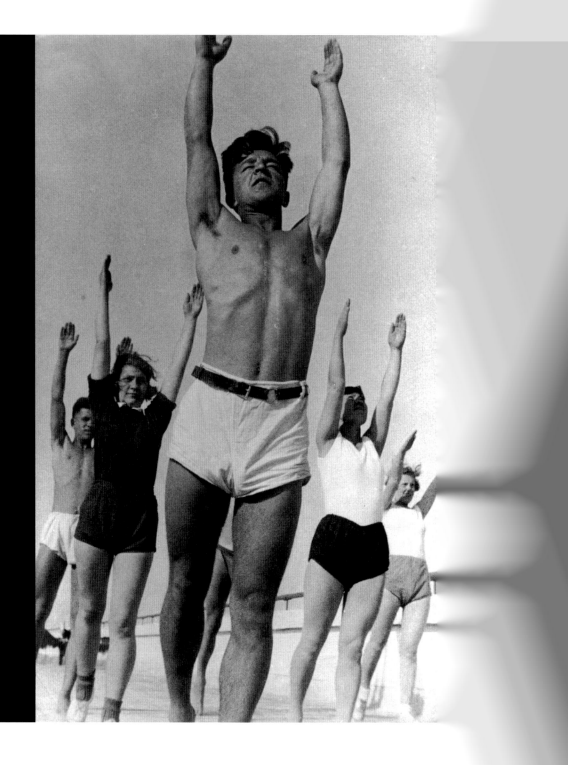

UTOPIA

Utopia was the title of a book written in 1516 by Sir Thomas More, an English civil servant in the court of Henry VIII. The fictional land of Utopia is a perfect country, where all is harmony and balance. But unlike the ancient idea of Arcadia, Utopia is consciously created by political man. As such, it has been a highly attractive idea to radicals and reformers. Since More's original work, countless philosophers, politicians, novelists, and artists have tried to create their own Utopia, laying down a formula for an ideal successful society. For example, William Morris envisions a new, model future for the people of England in *News from Nowhere* (first serialized in *Commonweal* in 1890). H.G. Wells also addresses Utopian themes in his novels *A Modern Utopia* (1905), *Men Like Gods* (1923), and *The Shape of Things to Come* (1933), as does James Hilton in *Lost Horizon* (1933).

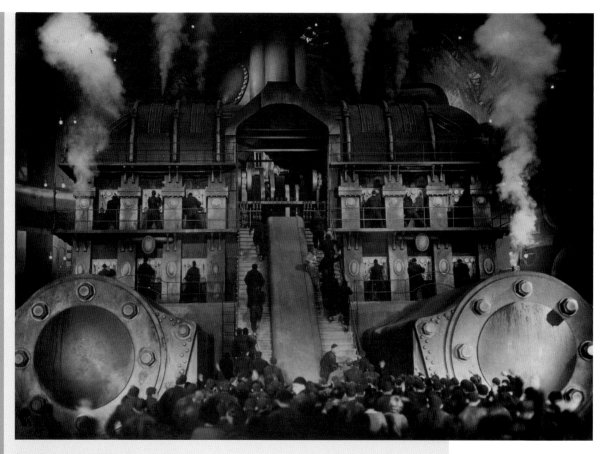

The Opposite of Utopia Many writers and artists have also depicted the opposite of Utopia: worlds where negativity, nightmare, and oppression reign, as in Aldous Huxley's *Brave New World* (1932), George Orwell's *Nineteen Eighty-Four* (1949), and much science fiction. Austrian filmmaker Fritz Lang's *Metropolis* (1926–1927) addresses political themes through futuristic style; and Charlie Chaplin's *Modern Times* (1936) satirizes the industrialization of society by pitting a hapless worker against the unforgiving machinery of Capitalism. These hellish, depressive, and sometimes satirical visions are frequently referred to as Dystopias.

Fritz Lang
METROPOLIS, 1926–1927
Film: c. 210 mins (later cut to 93 mins; restored to 147 mins in 2001), silent (accompanying music by Gottfried Huppertz), black and white
Produced by Erich Pommer, Universum AG, Germany

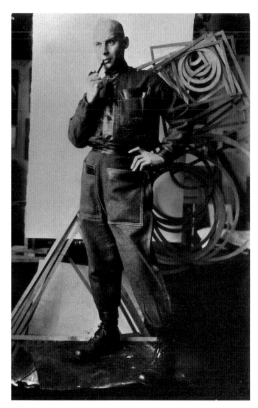

Mikhail Kaufman
RODCHENKO WEARING HIS
PRODUCTION CLOTHING IN FRONT
OF DE-INSTALLED SPATIAL
CONSTRUCTIONS, 1922
Photograph
Private collection

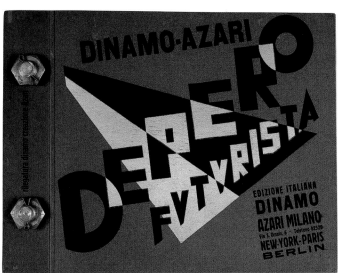

Fortunato Depero
DEPERO FUTURISTA (DEPERO
THE FUTURIST), 1927
Letterpress book
Merrill C. Berman Collection

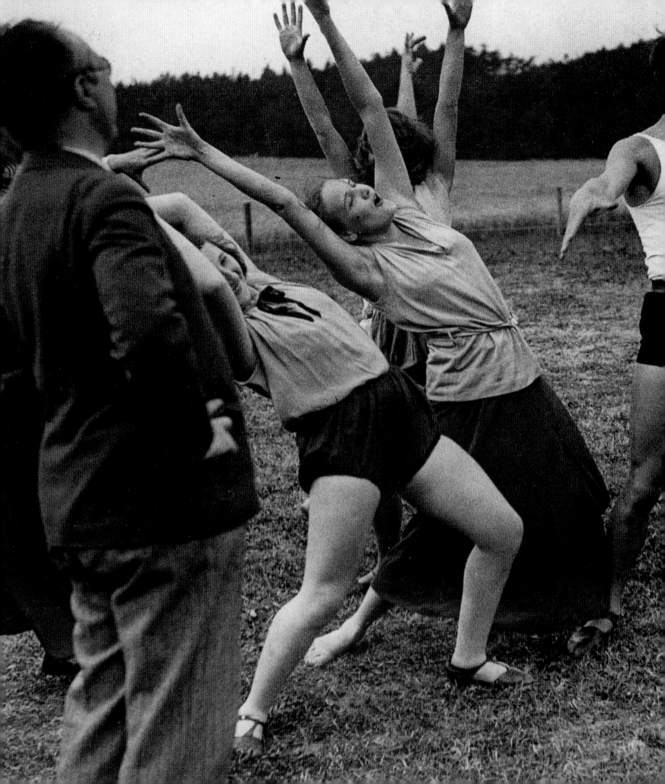

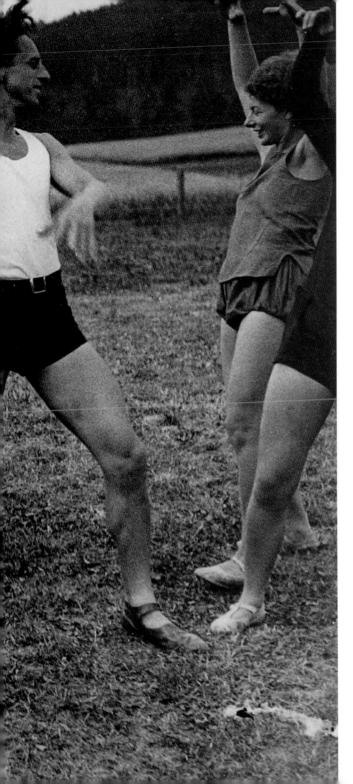

By the end of the nineteenth century many writers, along with an ever-increasing number of architects, designers, and craftspeople, were experimenting with Utopian ideas. Two styles that blossomed at the end of the nineteenth century, the Arts and Crafts movement and Art Nouveau, were heavily inspired by the desire for a perfect world. The contemporary writer Oscar Wilde made the celebrated comment that "a map of the world that does not include Utopia is not worth even glancing at, for it leaves out the one country at which humanity is always landing."

Modernist practitioners were indeed more Utopian than many of their predecessors. They specifically set out to create new and experimental ways to use design, architecture, and art to improve and perfect society. They believed that they could apply appropriate new technology, combined with a single, all-embracing methodology, to every part of the manufactured environment—buildings, furnishings, products, interiors, signage, posters, and clothing—and that this could significantly improve the physical and psychological condition of people.

This Utopian zeal, together with the political inspiration of the moment, gave the Modernists a powerful moral motivation to underlie their practice, and a mission to benefit humanity directly by producing art that would improve living standards. How their work looked was just one of their concerns; what it meant, and how it was used, were equally important.

Felix H. Man
LABAN GROUP, c. 1930
Gelatin silver print
Private collection

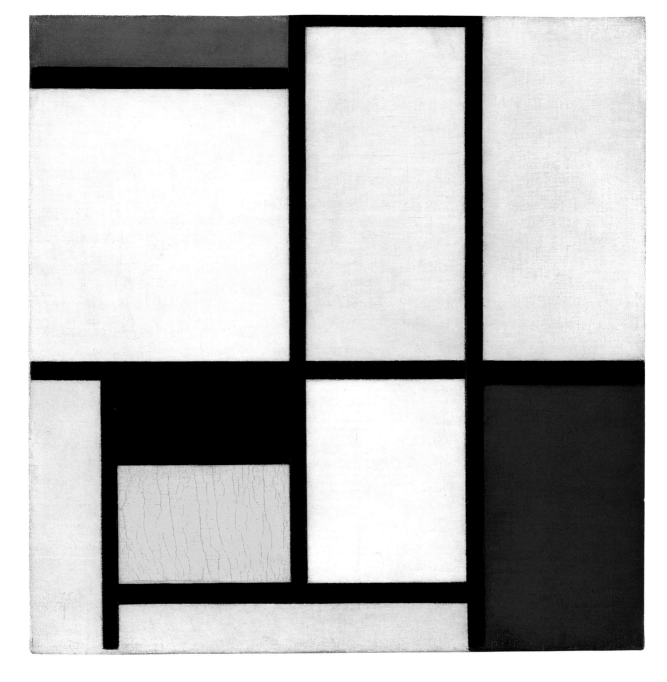

3

THE MODERN MOVEMENTS
AND THE MODERN LOOK

Mondrian was the most prominent member of the Dutch De Stijl movement, dedicated to the Utopian ideal of spiritual harmony through art. De Stijl artists attempted to derive universal aesthetic principles through pure abstraction and a reduction to the fundamental elements of form and color.

The key to Modernism is to see it as a collection of interrelated movements, flourishing in different degrees in a number of cities. The first of these movements was established by 1916. By 1927—as the initial phase of Modernism came to a climax with the Weissenhof Siedlung exhibition in Stuttgart—many countries had their own version of the new style.

During the 1930s the Modernist style matured and spread. Various expressions of Modernism then coalesced, giving it what was to become its keynote—the appearance of a single, ubiquitous, *international* style. Indeed, in the years following World War II, Modernism could be found nearly everywhere on the planet.

To understand the inaugural phase of Modernism, it makes sense to see it as comprising a number of core or primary movements, and secondary movements. These secondary movements started a little later, and often took their lead from the core movements. In some cases, these secondaries were very vigorous—and, ultimately, more influential than the core movements themselves. For example, strong secondary movements carried the Modernist message to millions of people in Britain, the former Czechoslovakia, Finland, Poland, Sweden, and the United States.

Katarzyna Kobro
SPATIAL COMPOSITION (4), 1928
Painted steel
Muzeum Sztuki Lodz, gift of the artist (MS/SN/R/18)

Understanding the essence of sculpture to lie in the relationships of forms in space, Kobro designed her works to encourage viewers to walk around them and experience their rhythms and recessions from different angles. Often her sculptures were painted in pure white, perhaps to adhere to her teacher Kasimir Malevich's association of white with the concept of infinity. Others, such as the sculpture shown here, were painted according to the De Stijl palette of primary colors and white, gray, and black.

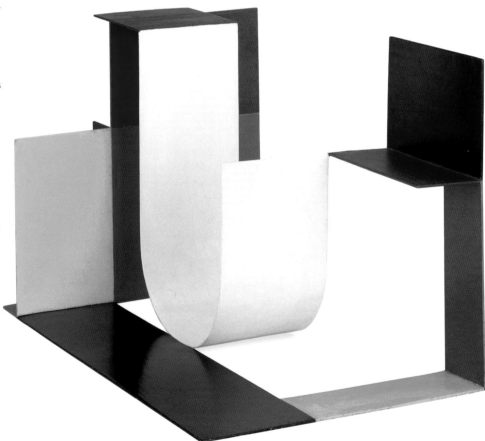

Alvar Aalto
SAVOY VASE, 1936
Mold-blown bottle glass
V&A: C.226–1987

Aalto first exhibited his
signature vase at the
Finnish Pavilion at the 1937
International Exhibition in
Paris. Its combination of
pared-down simplicity and
sinuous, curvilinear design
has made it one of the
world's most recognizable
glass objects—still in
production today.

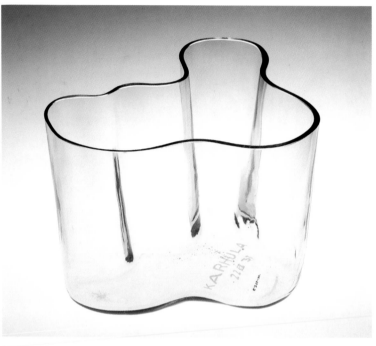

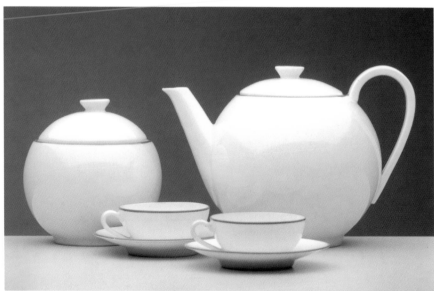

Ladislav Sutnar
TEA AND MOCHA SET,
1929–1932
Porcelain
The Museum of Decorative
Arts, Prague

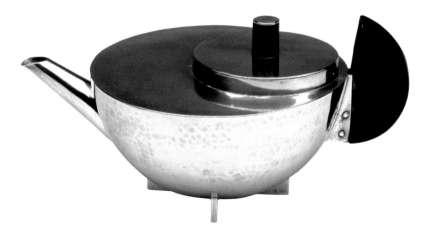

Brandt, the first woman to join the Bauhaus Metal Workshop in 1924, designed this silver teapot while she was still a student. With its sleek geometries, industrial aesthetic, and evident functionality, it is a quintessential Bauhaus object, representing a close union of art and technology. Although Brandt's original teapot was handmade, it was also used as a prototype for a mass-produced version.

But it was the core movements that gave Modernism its crucial impetus, initiating the style and consolidating it. These emerged in Italy (Futurism), the Netherlands (De Stijl), Germany (Bauhaus), France (Purism), and the former Soviet Union (Suprematism and Constructivism). But while these nations played host to subtly different versions of Modernism, a common set of attitudes and stylistic points of view held them in proximity. In fact, many of the most influential artists and designers were in personal contact across national boundaries, and many had gone through similar formative developments. Most strikingly, many Modernist designers and architects had been involved in various ways in the Cubist movement before 1918.

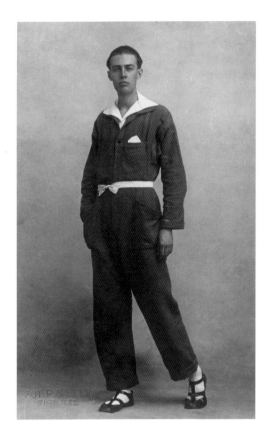

Cubism Though Modernism was principally concerned with design, architecture, graphics, and new technologies such as photography and cinema, Cubism—one of its great sources of power and inspiration—was primarily about revolutionizing painting. Invented by Pablo Picasso and Georges Braque in France, in 1907–1908, Cubism was a highly aggressive challenge to the canon of Western art. A new philosophy and visual language emerged that commanded artists to seek new ways of seeing the world, in relation to the flat surface of their canvases. With Cubism providing the impetus, the way was clear for Modernism to develop in its key geographic bases.

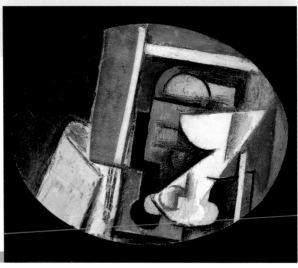

Pablo Picasso
UN VERRE SUR UNE TABLE (A GLASS ON A TABLE), 1913
Oil on canvas
Corcoran Gallery of Art, Washington, D.C.,
gift of Ingrid and Morton Leeds, 1998.7
Working in 1907–1908 with fellow painter Georges Braque, Picasso developed the artistic style that came to be known as Cubism—a style that challenged traditional modes of depicting space, volume, and mass. With its muted palette and multiple viewpoints, this small still life has many of the attributes of his early form of Analytic Cubism, combined with the use of collage and *papier collé*, characteristic of his later Synthetic Cubism. In this work, however, Picasso uses paint to mimic these effects, creating the illusion of overlapping paper through *trompe l'oeil* craftsmanship.

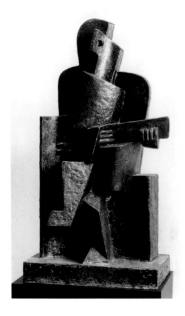

Jacques Lipchitz
GUITAR PLAYER, 1918
Bronze
Corcoran Gallery of Art, Washington, D.C., bequest of June Provines Carey, 1984.7.1
Like Picasso, whom Lipchitz befriended in Paris in 1909, the sculptor repeatedly examined the analogy between the guitar and the human form. Lipchitz employed the Cubist syntax more than any other sculptor, using the void as a positive element and articulating volume with a series of intersecting two-dimensional planes. In doing so, he helped overturn the traditional concept of sculpture as a solid surrounded by space. Along with the work of Modernist sculptor Alexander Archipenko, Lipchitz's bronzes reinvented the familiar sculptural subject of the human figure, making Cubism's spatial innovations both accessible and influential to artists for a generation.

Futurism, in Italy

Not surprisingly, Cubist forms, shapes, and attitudes proved highly attractive to those artists and practitioners who wanted to design a new world. By 1911, major offshoot movements had emerged out of Cubism. The first of these to engage directly with the modern world through design and architecture was Futurism. Based in the Italian city of Milan, the major Futurist artists, designers, and thinkers were obsessed with the machine: its forms, its speed, and its violence. Giacomo Balla, Antonio Sant'Elia, Filippo Marinetti, Fortunato Depero, and Umberto Boccioni, among others, pushed Cubist ideas into the machine age, and into the real world.

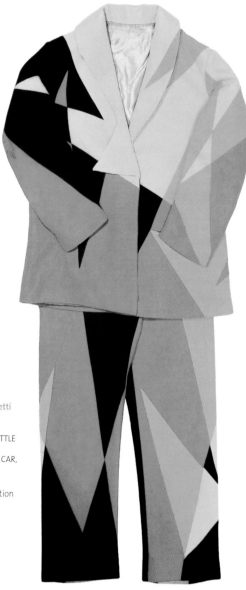

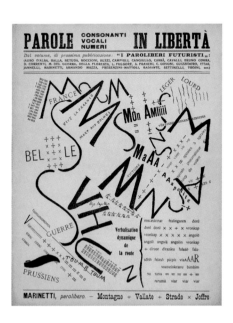

LEFT:
Filippo Tommaso Marinetti
WORDS (CONSONANTS VOWELS NUMBERS) IN FREEDOM/AFTER THE BATTLE OF THE MARNE JOFFRE INSPECTS THE FRONT BY CAR, 1919
Journal
Merrill C. Berman Collection

RIGHT:
Giacomo Balla
FUTURIST SUIT, c. 1920
Wool and cloth
Ottavio and Rosita Missoni Collection

Balla's fashion design was a direct translation of Futurist ideals and artistic strategies into clothing, all aimed at the ultimate goal of transforming Italy into a totally Futurist environment. For example, the brilliant colors and dynamic lines and angles of his men's suits were meant to dispense with moribund traditions and promote a modern machine aesthetic. Balla's clothes were designed to be visually exciting, but not durable: the idea was to promote a constant state of flux and innovation.

De Stijl, in the Netherlands

The De Stijl group was founded in 1916 by a number of like-minded Dutch artists and designers, led by the painter Piet Mondrian and the architect-artist Theo van Doesburg. Mondrian imbued his work with spiritual meaning; the abstract purity of his painting expressed a kind of universal harmony. Other famous adherents included the extraordinary architect-cum-furniture-designer Gerrit Rietveld, the architects Cornelis van Eesteren and J.J.P. Oud, and the painter-designers George Vantongerloo, Cesar Domela, and Bart van der Leck.

Vilmos Huszár
DE STIJL: MAANDBLAD GEWIJD AAN DE MODERNE BEELDENDE BOKKEN EN KULTUUR
(THE STYLE: MONTHLY MAGAZINE ON MODERN PLASTIC ARTS), issue containing vol. 3, no. 1 (November 1919) and vol. 3, no. 6 (April 1920), cover image
V&A: RC.M.30 and V&A: L.3323–1981

Gerrit Rietveld
SCHRÖDER HOUSE, 1924
Model made by G.A. van de Groenekan, c. 1950
Wood, plywood, cardboard, and glass
Stedelijk Museum, Amsterdam, donated by Rietveld c. 1951 (KNA2846)

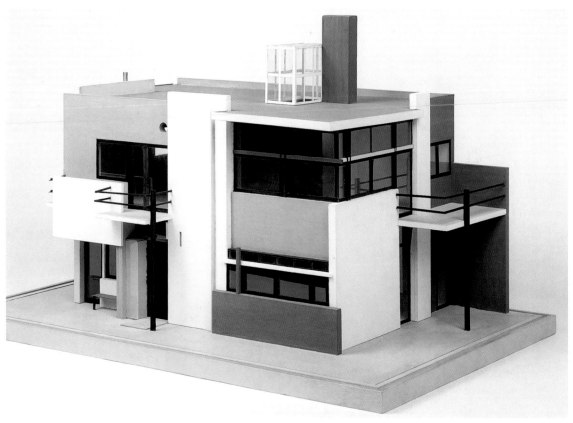

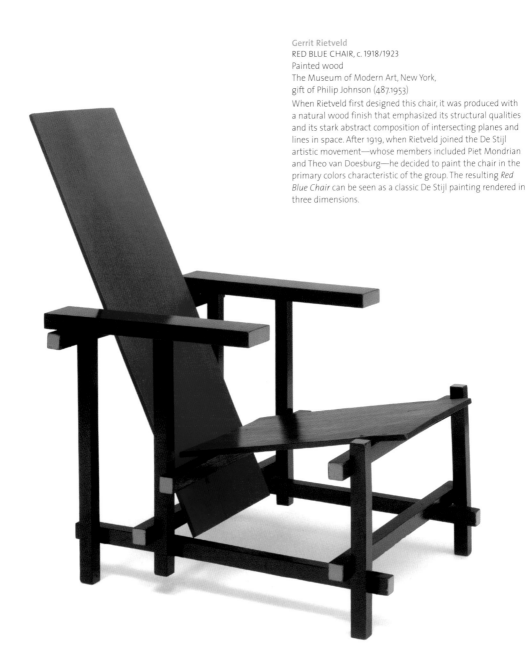

Gerrit Rietveld
RED BLUE CHAIR, c. 1918/1923
Painted wood
The Museum of Modern Art, New York,
gift of Philip Johnson (487.1953)
When Rietveld first designed this chair, it was produced with
a natural wood finish that emphasized its structural qualities
and its stark abstract composition of intersecting planes and
lines in space. After 1919, when Rietveld joined the De Stijl
artistic movement—whose members included Piet Mondrian
and Theo van Doesburg—he decided to paint the chair in the
primary colors characteristic of the group. The resulting *Red
Blue Chair* can be seen as a classic De Stijl painting rendered in
three dimensions.

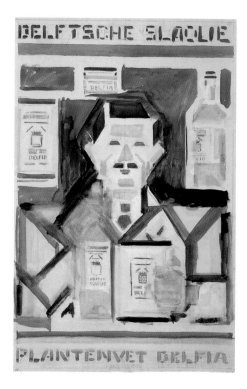

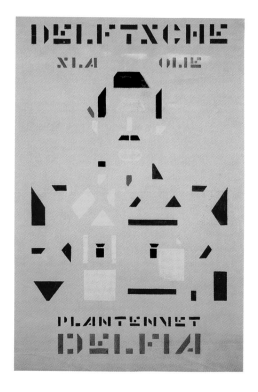

The De Stijl group—literally, "the style"—gathered around a magazine of the same name, edited by van Doesburg. The magazine both promoted the group's views and published the writings of other Modernist groups.

To a considerable extent, Mondrian and Rietveld provided the dominant stylistic approach. The collective output was heavily based on straight lines configured in informal grid patterns, together with the use of the primary colors blue, red, and yellow, normally in conjunction with black, white, and gray. This rigorous approach to forms, shapes, and colors was applied in an uninhibited way to paintings, graphic designs, building, and furniture designs. In this, the group picked up on ideas that had been current in avant-garde design circles since the early 1890s.

Bart van der Leck
DELFT SALAD OIL, 1919
Gouache and pencil
on board
Merrill C. Berman Collection

Bart van der Leck
DELFT SALAD OIL, 1919
Gouache and pencil
on board
Merrill C. Berman Collection

They seized especially on the idea that a single style might be applied to everything in the urban environment.

The De Stijl group collapsed in acrimony in 1931. However, the individual practitioners would go on to make some of their greatest Modernist works in later years.

The Bauhaus, in Germany

Not strictly a movement but a college, the Staatliches Bauhaus was founded in Weimar in 1919. It was the twentieth century's most important school of art and design by far. Bauhaus professors, students, and alumni made their extraordinary contribution in two ways. First, several of the most important designs for modern furniture, products, graphics, books, architecture, and theater were created there—along with

Herbert Bayer
MURAL DESIGN FOR
BAUHAUS STAIRWELL,
GERMANY, 1923
Gouache, pencil, cut paper
Merrill C. Berman Collection

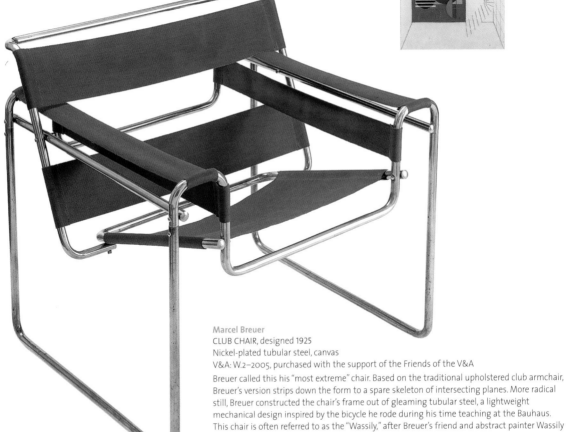

Marcel Breuer
CLUB CHAIR, designed 1925
Nickel-plated tubular steel, canvas
V&A: W.2–2005, purchased with the support of the Friends of the V&A

Breuer called this his "most extreme" chair. Based on the traditional upholstered club armchair, Breuer's version strips down the form to a spare skeleton of intersecting planes. More radical still, Breuer constructed the chair's frame out of gleaming tubular steel, a lightweight mechanical design inspired by the bicycle he rode during his time teaching at the Bauhaus. This chair is often referred to as the "Wassily," after Breuer's friend and abstract painter Wassily Kandinsky, who praised it when it was first made.

some of the century's most influential experiments in painting, sculpture, and photography. Second, the Bauhaus curriculum provided the foundation model for Western art education. Many schools still adhere to its essential teachings.

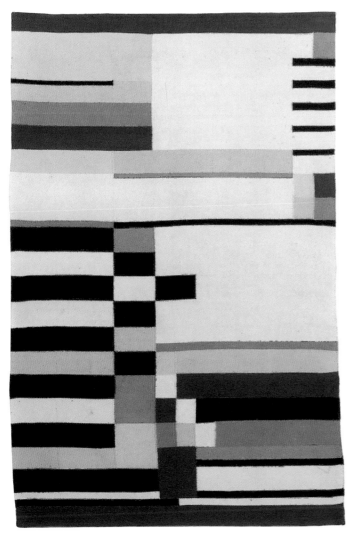

Ruth Hollós-Consemüller
WALL HANGING, c. 1930
Cotton and wool
Bauhaus-Archiv Berlin (N 421)
The abstract design of this wall hanging is characteristic of the Modernist Bauhaus in which it was produced, but its craftsmanship has its roots in local tradition. Hollós-Consemüller drew on historical weaving techniques to make the hanging, weaving it like a tapestry on an upright loom. As such, the object represents a merging of the handmade and the technological; the historical and the new.

The Bauhaus moved to Dessau in 1925, and then to Berlin in 1932, until it was closed by the National Socialist (Nazi) government in 1933. At this point many of the professors moved to London and America to continue their careers as teachers, artists, architects, and designers. Some were based in Boston, while others went to Chicago, where the New Bauhaus was founded by László Moholy-Nagy in 1937.

The first director of the Bauhaus was architect Walter Gropius. Strictly speaking, the Bauhaus did not teach the fine arts—its curriculum was focused on architecture and design. But Gropius did employ artists to teach. Indeed, Bauhaus teachers formed a constellation of Modernist stars, including Josef Albers, László Moholy-Nagy, Marcel Breuer, Lyonel Feininger, Johannes Itten, Wassily Kandinsky, Paul Klee, Oskar Schlemmer, Ludwig Mies van der Rohe, and many others.

László Moholy-Nagy
TELEPHONE PICTURE EM2, 1922
Porcelain enamel on steel
The Museum of Modern Art, New York, gift of Philip Johnson in Memory of Sybil Mololy-Nagy (91.1971)

Because the Bauhaus was not a style or a movement like De Stijl or Purism, but a school, its products did not adhere to a singular visual approach. However, the school still had important common elements. In design and architecture, Bauhaus work was typified by a novel use of new technology and innovative industrial materials such as plastic and metal, adherence to abstract geometry, and an interest in aggressively simplified forms. In fact, the Bauhaus provided the twentieth century with some of its archetypal forms: it is difficult to imagine the modern office or kitchen in the absence of Bauhaus innovations.

Marianne Brandt
KANDEM-BEDSIDE LIGHT, BASIC MODEL NO. 702, 1928
Lacquered sheet steel
Bauhaus-Archiv Berlin (BHA 3883)

Trude Petri
TEA SERVICE: NEU-BERLIN,
1931
Glazed porcelain
Die Neue Sammlung—
State Museum of Applied
Arts and Design, Munich

Wilhelm Wagenfeld
TEA SERVICE, 1931
Mold-blown, heat-resistant,
boro-silicate glass
V&A: C.31 to D—1980

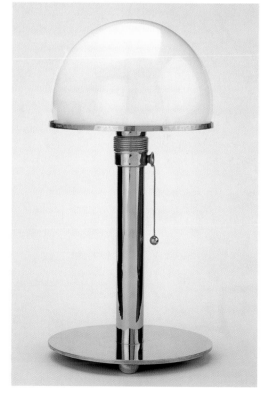

Wilhelm Wagenfeld
TABLE LAMP MT8/ME2, c. 1924
Nickel-plated brass and opaque glass
V&A: M.28 to A—1989

Wagenfeld's table lamp, also known as the "Bauhaus lamp," has a clarity of
function and of materials that makes it one of the exemplary products of the
school's Metal Workshop. The geometric globe design—devised to provide a mix
of both ambient and direct light for reading—is simple in conception. It proved
difficult to produce, however, and was therefore manufactured outside the
Bauhaus workshops.

Purism, in France

Purism was centered on the careers of two men: Charles-Édouard Jeanneret, known universally by his nickname Le Corbusier—"the Beak"—and the painter Amédée Ozenfant. These two practitioners masterminded the Purism movement and edited its journal, *L'Esprit Nouveau* (The New Spirit). Le Corbusier's cousin, Pierre Jeanneret, and the painter Fernand Léger were also strongly associated with Purism in the early 1920s.

Le Corbusier was arguably the most important architect of the twentieth century, and a seminal influence on the way buildings were built and cities planned. He famously decreed that "a house is a machine for living in"; and his general approach to design and architecture was to foreground function. Having said this, it is important to remember that Le Corbusier remained a painter under the lifelong influence of Cubism, and was passionately committed to the importance of art as an improver of people's lives.

Purist forms make use of an informal geometry. However, unlike most other modern movements, the preference is often for pastel shades rather than strong primary colors. In architecture, Purism was powerfully committed to concrete, steel, and glass. Purist furniture is undecorated, and often constructed from tubular steel.

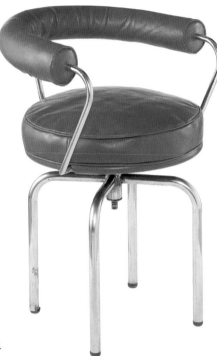

Charlotte Perriand
FAUTEUIL PIVOTANT
(SWIVEL ARMCHAIR), 1928
Tubular steel and leather
upholstery
V&A: W.35–1987

Perriand designed this chair just before she met Le Corbusier and joined his studio. Its form is a reconciliation of opposites. With a frame made of utilitarian tubular steel and a seat and back made from luxurious padded leather, it is meant to encircle and cradle its sitter.

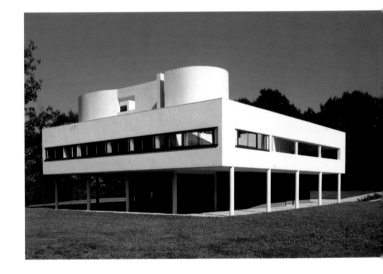

Le Corbusier
VILLA SAVOYE, POISSY, FRANCE, 1928

A prime example of Le Corbusier's purist style, the Villa Savoye, in the suburbs of Paris, exemplifies the architect's vision of a house as a *machine à habiter* (machine for living in). The simple white exterior, with its associations of newness, purity, and hygiene, is complemented by an interior living space defined by its open floor plan, industrial-inspired ribbon windows, and built-in furniture.

Suprematism and Constructivism, in the Soviet Union (USSR)

Suprematism and Constructivism, two movements that emerged in revolutionary Russia during the course of World War I, tend to be bracketed together. This is not entirely unreasonable, but they were in fact two distinct movements with distinctly different emphases. As a result, they produced noticeably different art and design.

Suprematism was principally an abstract art with a mystical or metaphysical dimension, based on the use of informal geometric forms in strong colors. It was typified by squares, triangles, circles, and trapezoids in saturated primary colors, on plain, flat backgrounds.

The style was developed by painter Kasimir Malevich during World War I. Malevich was one of the very first artists to create pure abstract paintings. After Malevich, the painter, architect, and seminal graphic designer El Lissitzky was the most prominent Suprematist artist.

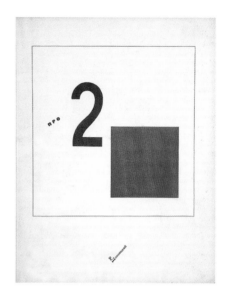

El Lissitzky
STORY OF TWO SQUARES, 1922
Book
Merrill C. Berman Collection

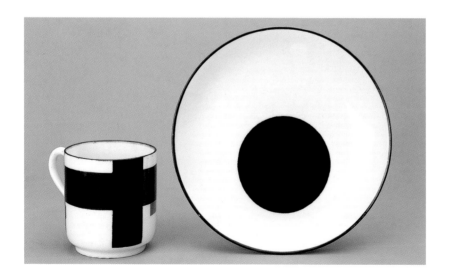

Nikolai Suetin
TEACUP AND SAUCER, 1923
Porcelain and polychrome overglaze painting
Porcelain Museum, State Hermitage Museum, St. Petersburg

The visual language of this cup and saucer, consisting of stark black and red geometric forms on a white background, is derived from the basic vocabulary of the artistic style of Suprematism. Members of the Suprematist *Unovis* group, formed by Suetin's teacher, Kasimir Malevich, were dedicated to the Utopian ideal of extending the style into everyday life, using such media as architecture, typeface, and fabric design. With the production of this china, *Unovis*'s activities were successfully realized in the manufacturing sector.

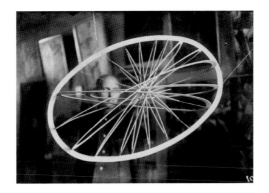

Constructivism, the related movement, was principally sculptural—its name derived from the idea of "construction." It was led by Vladimir Tatlin, Naum Gabo, László Moholy-Nagy, and Antoine Pevsner.

Constructivist sculpture is usually machine-like, geometric, and sometimes meant to be in motion. A typical Constructivist sculpture might take the shape of a metallic form resembling the inner part of a machine. It might also be imposing. Tatlin, rather notoriously, designed a giant tower to celebrate the Russian Revolution. Far bigger than the Eiffel Tower, Tatlin's *Monument to the Third International* would have required all the iron and steel then available in Russia for its construction. Not surprisingly, it remained in model form—a Modernist fantasy.

Vladimir Tatlin
MONUMENT TO THE THIRD INTERNATIONAL, 1920
Tatlin's Constructivist tower was planned as the headquarters of, and a grand monument to, the Russian Bolshevik Comintern. It was intended to stand more than 1,300 feet high and to contain several rotating geometric structures, and visitors were to travel through its central spiral form with the aid of various mechanical devices. However, due to its high cost and the challenges posed by the Russian civil war, the tower was never built. The wooden models that exist today remain as poignant symbols of the visionary, yet ultimately impractical world that so many modern artists hoped to construct.

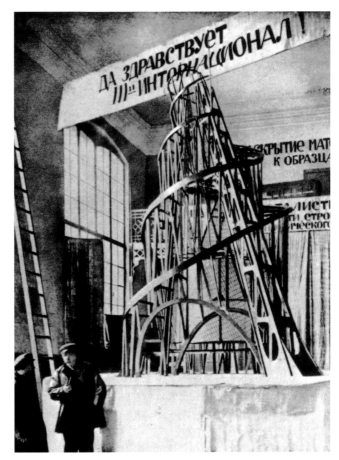

Who Created the First Abstract Art?

Kasimir Malevich, leader of the Suprematists, has sometimes been identified as having made the first truly abstract painting. In fact, he probably did not—but this particular art historical debate is still going on. Other contenders are the Frenchman Robert Delaunay, the Russian Wassily Kandinsky, and the Czech painter František Kupka. Part of the debate has to do with the meaning of abstraction. Pure abstract painting, or nonobjective painting, uses forms and shapes that are completely invented, and which do not refer to things in the real world. Much painting that might appear superficially abstract actually contains references to things the artist has observed. So, arguably, this is not abstract painting.

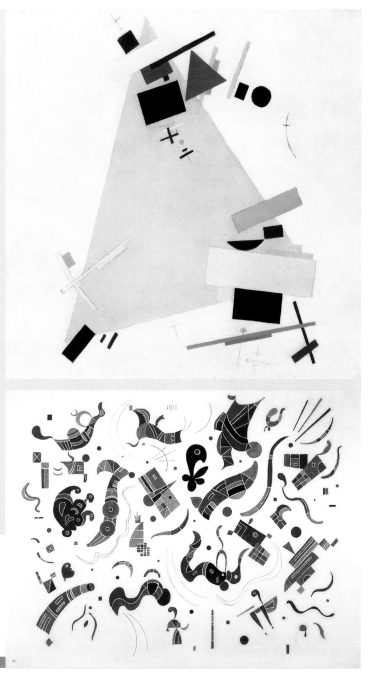

TOP: Kasimir Malevich
DYNAMIC SUPREMATISM, 1916
Oil on canvas
Tate, London, purchased with assistance from the Friends of the Tate Gallery, 1978 (T 02319)

RIGHT: Wassily Kandinsky
RELATIONS, 1934
Oil and sand on canvas
The Kreeger Museum

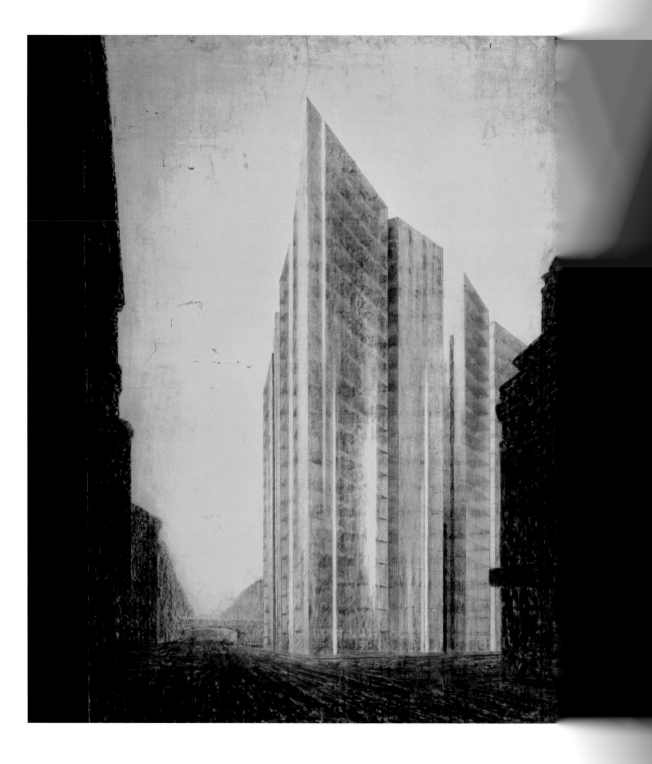

THE INTERNATIONAL STYLE

Ludwig Mies
van der Rohe
FRIEDRICHSTRASSE
SKYSCRAPER PROJECT,
PERSPECTIVE FROM NORTH,
1921
Charcoal and graphite on
tracing paper, mounted
on board
The Museum of Modern
Art, New York, Mies van der
Rohe Archive, gift of the
architect (1005.1965)
Mies van der Rohe
developed his revolutionary
design for a glass-coated
skyscraper for a
competition to build a
Berlin office building. This
drawing was likely created
for presentation purposes.

In 1932, The Museum of Modern Art in New York opened a landmark exhibition that detailed many of the advances made in international architecture since 1922. Organized by Philip Johnson, the founder of the museum's Department of Architecture and Design, this exhibition introduced modern architecture to the American public. It helped redefine Modernism by grouping such well-known practitioners as Le Corbusier, Walter Gropius, Gerrit Rietveld, and Ludwig Mies van der Rohe. The title of the exhibition's catalogue was *The International Style: Architecture Since 1922*.

In the influential catalogue, Johnson and co-author Henry Russell Hitchcock wrote:

Today a single new style has come into existence. The aesthetic conceptions on which its disciplines are based derive from the experimentation of the individualists . . . This contemporary style, which exists throughout the world, is unified and inclusive, not fragmentary and contradictory like so much of the production of the first generation of modern architects.

Cornelis van Eesteren
COMPETITION DESIGN FOR A SHOPPING STREET WITH HOUSING ABOVE IN DEN HAAG, 1924
Ink, gouache, and photo-collage mounted on board
Nederlands Architectuur Instituut, Rotterdam (III 250)

This shopping street design is an architectural translation of De Stijl formal qualities. Van Eesteren had been trained in the Dutch brick-house tradition, but has here created a plan that is wholly modern in its emphasis on plane and volume (highlighted by the use of primary colors) and in its attention to the unity of the block as a whole.

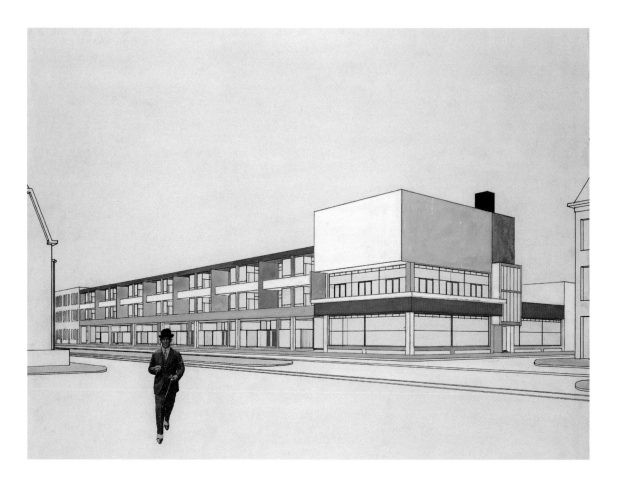

The most common characteristics of International Style architecture are found in the simplification of form, the architect's regard for a structure's volume rather than its mass, and its flow of space rather than its symmetry. Modernist architects and designers frequently called attention to the interior structure of a building or object, rejecting the use of architectural ornament. Furthermore, their use of glass façades and open interior spaces created a transparency of style that was both industrial and geometric. Their designs often stressed the function of a building over its form, working toward an aesthetic that encompassed social need and community development, as well as a building's ostensible purpose. For example, Mies van der Rohe's plans for the Friedrichstrasse Skyscraper Project in Berlin show a supporting steel skeleton that would release the exterior walls from their load-bearing function. Mies dematerialized the building's bulk and replaced it with an entirely glass surface that would both transmit and reflect light.

At first, the very fact that these characteristics were identified as a "style" contradicted the typical Modernist suspicion of rules, of anything that might regulate their art. But the connection of architectural design to industrial production and new technologies caused leading practitioners to build solutions that served their social agenda of producing housing and work-space that were both affordable and practical.

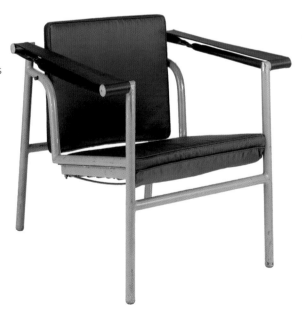

Le Corbusier, Pierre Jeanneret, and Charlotte Perriand
FAUTEUIL À DOSSIER BASCULANT, 1929
Painted tubular steel, metal springs, silk cushion covers
V&A: W.31-4–1987
This swing-back armchair was one of a series of chairs designed by Le Corbusier for specific functions. Distinct from the chaise longue (meant for relaxing) and the club chair (meant for luxury and comfort while reading or talking), this chair was meant for working. With its leather-strap arms, it was based on the traditional wooden "colonial chair" and kept its sitter upright and alert.

A Fundamentally New Attitude to Architecture

Walter Gropius, the German architect, teacher, and founder of the Staatliches Bauhaus, helped forge many connections between the visual arts, architecture, design, and crafts movements. He also stressed the importance of emerging relationships between arts and industry. In his 1925 book *Internationale Architektur* he wrote that "a fundamentally new attitude to architecture is emerging in all cultures simultaneously."

Living in the Machine When the Bauhaus moved to Dessau in 1925, Gropius designed an asymmetrical group of new buildings to house the school, using industrial, factory-like blocks sheathed in glass. Completed in 1926, these buildings provided studio, production, living, and administration spaces. This innovative, integrated design helped promote the school's mission of bringing together the technical study of art, architecture, industrial and graphic design, and photography—all in an industrial setting. As Gropius put it, "The Bauhaus believes the machine to be our modern medium of design and seeks to come to terms with it." The Bauhaus was not alone. At virtually the same time, French Modernist architect Le Corbusier (Charles-Édouard Jeanneret) declared that "A house is a machine for living in."

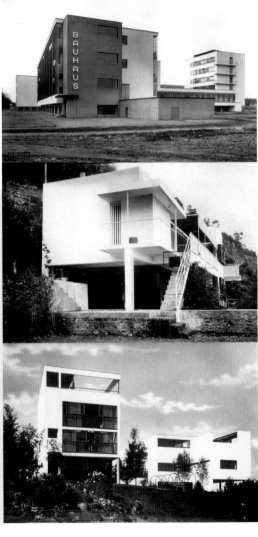

TOP: Walter Gropius
BAUHAUS, DESSAU, 1926
Photograph by Lucia Moholy, 1927
Bauhaus-Archiv Berlin

CENTER: Eileen Gray and Jean Badovici
E1027, ROQUEBRUNE-CAP-MARTIN,
1926–1929
Collection Alberto Sartoris

ABOVE: Le Corbusier and Pierre Jeanneret
SINGLE AND DOUBLE HOUSES,
WEISSENHOF HOUSING ESTATE,
STUTTGART, 1927
Collection Alberto Sartoris

Mass Construction for the
People's Century

The social philosophy of the International Style led to designs for mass-produced or large-scale worker housing, enabling high-quality and livable homes to be constructed inexpensively in and near urban centers.

Ernst May and C.H. Rudloff
BRUCHFELDSTRASSE ESTATE,
FRANKFURT, 1926
Nederlands Architectuur
Instituut, Rotterdam

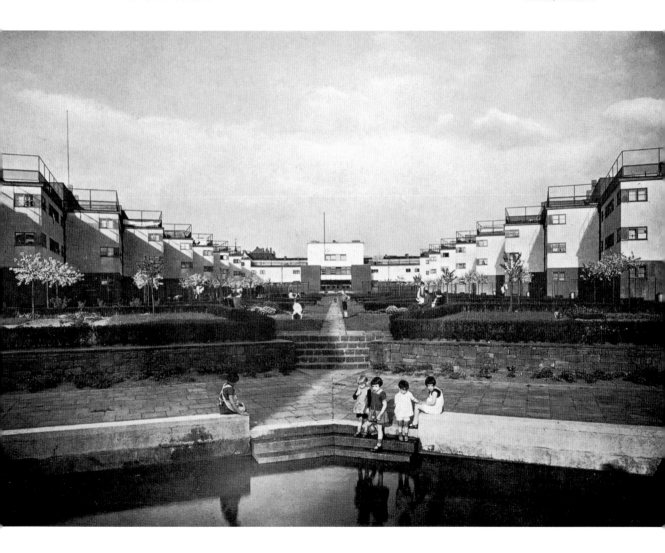

J.J.P. Oud
PLAN OF GARDEN AND ROW HOUSES AT WEISSENHOF, 1926–1927
Isometric drawing: ink, pencil, and pen on tracing paper
Nederlands Architectuur Instituut, Rotterdam

For example, Le Corbusier's *Maison Citrohan II* (1922) was a design for a standardized, prefabricated home. The Weissenhof Siedlung (Housing Estate) was built in 1927 as part of a housing exhibition in Stuttgart. Buildings at Weissenhof were designed by a number of the pioneers of Modernist architecture, including Ludwig Mies van der Rohe, Bruno Taut, Peter Behrens, Le Corbusier, J.J.P. Oud, and Walter Gropius. There were several types of homes exhibited, from low-income housing to middle-class, and each experimented with new building techniques and materials, open-plan designs, and prefabricated components. The Utopian idealism of the International Style was both praised and criticized; it was the first time such a variety of avant-garde architecture had been publicly scrutinized.

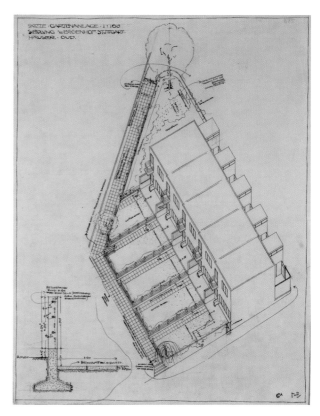

Mart Stam
STAHLROHRMÖBEL FOR HOUSE NO. 28 AT THE WEISSENHOF HOUSING ESTATE, STUTTGART, 1927
Deutsches Architekturmuseum, Frankfurt-am-Main

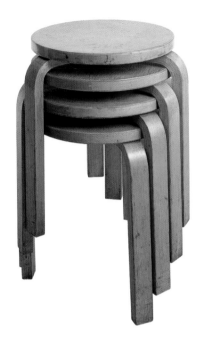

Aalto collaborated with Otto Korhonen to design these three-legged stools. Although simple, they are based around an element that Aalto considered his most significant contribution to furniture design: the curving leg that serves as both vertical and horizontal support. In the 1930s, it became possible to mass-produce these solid birch L-shaped legs, enabling large-scale production of this stackable, space-saving object.

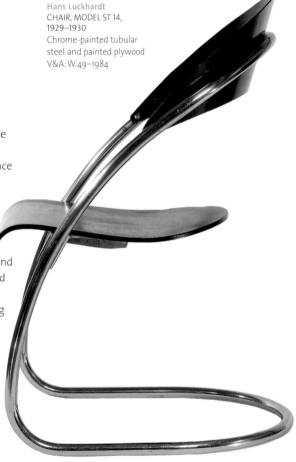

As the International Style gained acceptance during the late 1920s, becoming the dominant approach to Modernist architecture, its influence spread throughout Europe. The style has left a particularly rich legacy in the Netherlands, the Soviet Union, Sweden, Finland, and Italy.

The style became crucial for the development of architecture in America, too. The Viennese architects Rudolf Schindler and Richard Neutra moved to the United States and developed their own experiments, inspired by both European and American idioms—drawing in particular on the work of Frank Lloyd Wright.

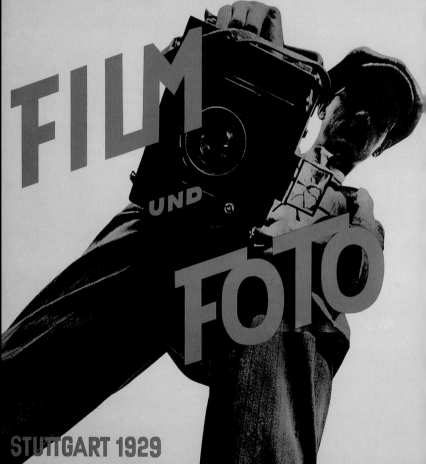

THE MODERN PHOTOGRAPH AND FILM

Photography fractures our normal perception of time and space. A photograph or film can visually take us into the past or symbolically transport us to another place. In doing so, these relatively new technologies prompt us to question the ambiguous relationship between art and reality; and in the first decades of the twentieth century artists were quick to explore these ambiguities. They experimented with new photographic forms and methods of reproduction that could trigger memories, tell stories, present abstract visions, or invoke new worlds of factual or fantastic proportion. Then, between 1918 and 1940, Modernist artists seized on the unique opportunities offered by the camera to redefine the way we see the world.

A New Vision in Photography and Film

After World War I, artists began to use the tools and aesthetic styles of mass culture to address both artistic and political issues, and to convey their ideas to a larger audience. Photographs and films were ideal mediums because they could be widely distributed through newspapers, magazines, and theaters.

This tended to focus more attention on the way the camera works—its technology. By looking through a lens, artists could isolate details of city buildings, factories, and machine parts in order to explore visually the design of manufactured environments. This new vision was prompted by the graphic potential of photographic framing. But photographers and filmmakers were also strongly influenced by the simplified, unornamented, and abstracted forms of Modernism seen in architecture, design, and the visual arts.

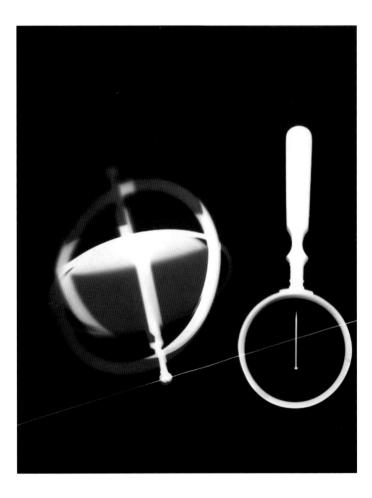

Man Ray (Emmanuel Radnitzky)
RAYOGRAPH, 1922
Gelatin silver print
The Museum of Modern Art, New York, gift of James Thrall Soby (112.1941)

Much of Man Ray's best-known work was made through the technique of the photogram, or "rayograph," as he referred to it. To make his rayographs, he placed objects—in this case a gyroscope and a straight pin laid on top of a magnifying glass—on light-sensitive paper, which he then developed without using a camera or other mediating device. Such a method was appealing to Man Ray and other avant-garde artists of the time because of its associations with spontaneity and immediacy, and its direct relationship with the materials.

Paul Strand
AKELEY MOTION PICTURE CAMERA, 1922
Gelatin silver print
The Metropolitan Museum of Art, New York (1987.1100.3)

Photography is Drawn into Fine Art

In 1911–1912, the Cubist artists Pablo Picasso and Georges Braque began to use materials from the real world in their paintings: objects such as printed oilcloth and newspaper. They also stenciled letters onto the surface of their works, and stuck actual manufactured objects directly onto their painted illusions.

In the next development, Dada artists such as Kurt Schwitters and Hannah Höch added photography to this process. They combined scraps of debris with ironic typography and photographs in collages that represented the fragmentary experience of city life in post-war Germany and Switzerland.

Meanwhile, a collection of photographers, graphic artists, and filmmakers—including László Moholy-Nagy, Alexander Rodchenko, and Dziga Vertov—rejected pictorial and narrative traditions. They embraced technological invention in search of revolutionary new ways to transform modern life.

Experimentation, Exchange, and Combination

During the 1920s, Weimar Republic Germany (and especially Berlin) became a crossroads for European avant-garde artists.

In 1923, Hungarian-born László Moholy-Nagy joined the faculty of the Bauhaus. He became one of the principal theoreticians of Modernist photography and film, and was directly inspired by the simplified forms of the artists Kasimir Malevich, El Lissitzky, and Piet Mondrian—and by the activism of Berlin Dada artists and the Hungarian writer and artist Lajos Kassák.

In both his art and his writing, Moholy-Nagy questioned how artists could best address the global changes occurring in economics, technology, and politics. His most notable early writings appeared in the periodical *MA*, which he edited with Kassák. Here, he helped introduce Russian Constructivism to European artists, arguing that new art should be rooted in modern technology and the character of the time.

LEFT: László Moholy-Nagy
BAUHAUSBÜCHER (BAUHAUS BOOKS), 1929
Brochure
V&A, National Art Library (JP Box 22b)

RIGHT: Albert Renger-Patzsch
FLOWER, late 1920s
Gelatin silver print
Corcoran Gallery of Art, Washington, D.C., Museum Purchase, Brenda and Robert Edelson Collection, 1998.37
Renger-Patzsch came of age during the rise of *Die Neue Sachlichkeit* (The New Objectivity) movement. Reacting against pictorialism, which employed soft-focus, painterly effects to legitimize the relatively new art of photography, Renger-Patzsch argued for an ascetic, rigorous, empirical art that was descriptive and free of sentiment. Along with his colleagues, he is credited with building a typological vision for photography, cataloging the world one person, one building—or, as we see here, one flower—at a time. In this way he searched for truth in detail and difference, rather than in uniformity and multiplicity.

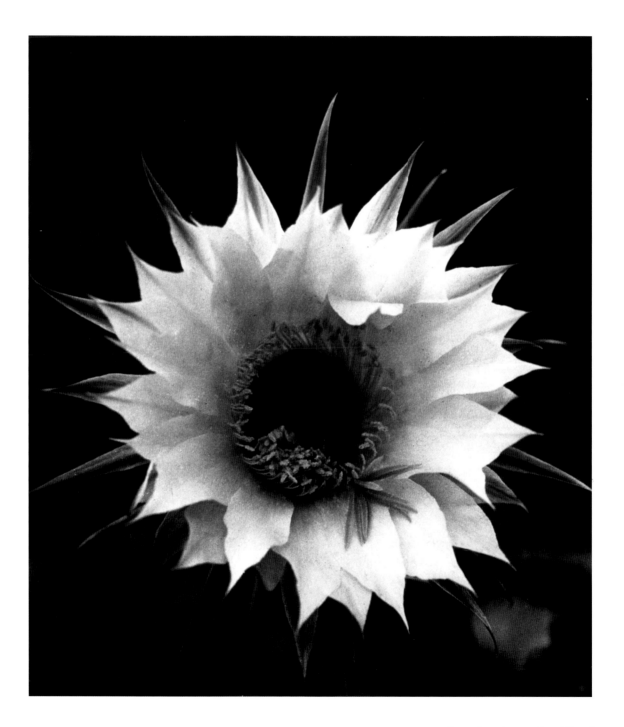

In his photographic art, Moholy-Nagy carried out early experiments with photograms—images made by placing objects onto the surface of photographic paper, exposing them to light, and developing the paper—to create a picture made without the use of a camera. Like some Dada artists, including Höch and John Hartfield, Moholy-Nagy also began incorporating photomontage techniques into his work, cutting out and recombining different photographs into one image. This process, at different times, also included drawing, words, or other graphic elements—combining disparate pieces in often surreal or unexpected ways. Moholy-Nagy's more traditional photographs are often shot from steep angles: looking up or down at cropped architectural details or truncated human figures, as if seen from the perspective of an airplane. In these images the dynamic interplay of light, shadow, and form is far more important than the documentary record of a place or person.

In some ways, each of Moholy-Nagy's influential experiments with photography typifies the contradictions he faced in reconciling his vision: an art that could both embrace the social changes of the time and retain sufficient aesthetic potency to represent a genuine departure.

Lucia Moholy
PORTRAIT OF LÁSZLÓ
MOHOLY-NAGY, 1926
Gelatin silver print
Bauhaus-Archiv Berlin
(BHA 7896)

Gustav Klutsis
UNDER THE BANNER OF
LENIN FOR SOCIALIST
CONSTRUCTION, 1930
Color lithograph
V&A: E.404–1988

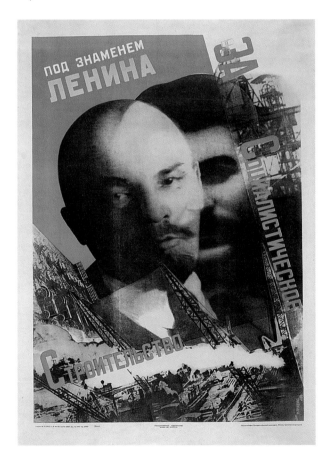

Photomontage and Juxtaposition in Russia

In Russia, Alexander Rodchenko was another artist profoundly affected by the experimentation and exchange of information between Russian avant-garde artists such as Tatlin, Malevich, Gustav Klutsis, and Lyubov Popova. Trained as a graphic artist and painter, Rodchenko taught and wrote about the relevance of art in the new Socialist society. Like Moholy-Nagy, he began to work with photography and photomontage in the early 1920s. He created posters for the Soviet government using photomontage techniques, and in 1923 began to collaborate with the acclaimed poet Vladimir Mayakovsky.

Featuring the oblique angles and distorted perspectives of the most evocative Modernist design, Rodchenko's photographs are often experiments in radical seeing. They not only push the boundaries of traditional composition, but also create dizzying views: works that echo the feeling of urban, mechanized life, almost as though his camera were fixed to the helmet of a construction worker building the brave new world.

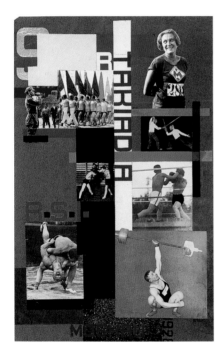

Gustav Klutsis
SPARTAKIADA, MOSCOW, 1928
Halftone photographs, gelatin silver prints, colored paper, paste
Merrill C. Berman Collection

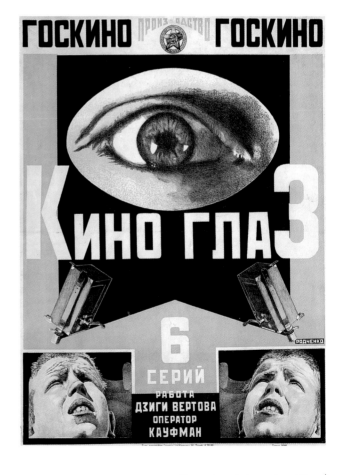

Alexander Rodchenko
KINO-EYE/DIRECTOR DZIGA VERTOV, 1924
Offset poster
Merrill C. Berman Collection

Rodchenko's photographic perspective is similar to the style that Dziga Vertov developed in his films *Kino Eye* (1924) and *Man with a Movie Camera* (1929). Rodchenko had, in fact, designed posters for some of Vertov's films, and his interest in juxtaposing contrasting ideas through photomontage is akin to Vertov's cinematic experiments with filmic montage. By assembling clips of film in novel sequences—sometimes mixing up traditional filmmaking structuring devices such as continuity, linear time sequences, and narrative—Vertov rebelled against literary form in cinema, developing and mastering an editing style known as montage. This meant that when two different shots were assembled through editing, their combined meaning could be altered, manipulated, and reinforced through their juxtaposition.

In this way montage could be used to produce powerful visual and emotional effects. Vertov's syncopated flow of imagery through time, and the off-kilter collision of disparate pictures, helped establish a new Modernist language in filmmaking—one that strongly influenced later documentary and narrative cinema.

Dziga Vertov
THE MAN WITH A MOVIE CAMERA (CHELOVEK S KINOAPPARATOM), 1929
Film: 65 mins, silent, black and white
Produced by VUFKU, Kiev, USSR

A New Technological Art

The strong connection between Modernism and new techniques of mechanical reproduction also helped connect visual artists to film. For example, Viking Eggeling and Hans Richter put their sequential drawings in motion by cinematically animating geometric shapes. Meanwhile, many avant-garde filmmakers were gripped by the ability of cinema to represent or document the real world in real time—and therefore to change or transform it. Film was seen as a means to create new, technological art that could supersede the limited ability of painting to describe the modern world.

The early montage aesthetic of French director Abel Gance, and of Soviets Sergei Eisenstein, Esfir

Fernand Léger and Dudley Murphy
LE BALLET MÉCANIQUE (MECHANICAL BALLET), 1924
Film: c. 12 mins, silent (accompanying music by George Antheil, 1925), black and white (some copies tinted)

Shub, Lev Kuleshov, and Vertov, helped boost the work of other visual artists, such as René Clair, Man Ray, and Fernand Léger—whose *Le Ballet Mécanique* (1924), made with Dudley Murphy, fractured any sense of narrative continuity by using a combination of superimposed images, details of machines, and dancing utensils, texts, and puppets.

In 1920, the photographers Charles Sheeler and Paul Strand demonstrated their interest in experimental film through their collaboration in the elegiac short film *Manhatta*.

A Day in New York City *Manhatta* depicts a day, from sunrise to sunset, in New York City. Using quotations from Walt Whitman as intertitles, Sheeler and Strand established a rhythmic structure that moves back and forth between images of almost abstract, urban architecture, construction, ships, and an atmospheric look at the sky, clouds, water, and steam over the harbor.

The overt comparison between man-made, solid structures and ethereal nature evokes Whitman's focus on the relationships between urban energy and the natural world.

Sheeler, who was also an important painter, went on to photograph the Ford Motor Company's River Rouge automobile plant. At the time this was perhaps the most advanced factory in the world, where Ford perfected the concept of assembly-line mass production. Sheeler's images portray the giant machinery as Modernist architectural icons, in which precise and ordered technology is used to construct the modern transportation systems that fuel the nation's economy.

Sheeler combined several of his River Rouge photographs in a triptych titled *Industry*, an altar-like design for a 1932 mural proposal. In the center panel, several different images are superimposed in an almost surreal display of industrial power; crossed conveyor buildings lend sacred significance to the iconic role of the machine.

Charles Sheeler
INDUSTRY, 1932
Gelatin silver prints with collage
Art Institute of Chicago, Julian Levy Collection, gift of Jean and Julian Levy

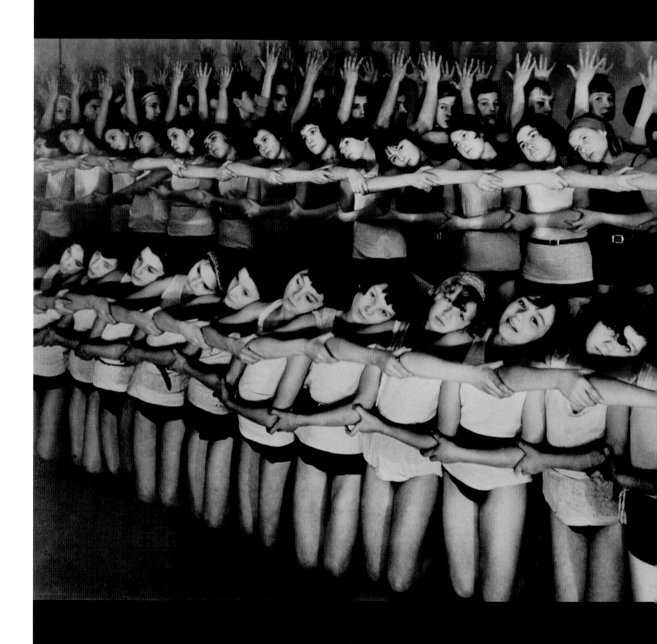

A TOTAL ART: MODERNISM IN ART AND LIFE

Margaret Bourke-White
MACHINE DANCE, MOSCOW
BALLET SCHOOL, 1931
Gelatin silver print
Corkin Shopland Gallery,
Toronto

The Modernists believed that all of the arts were intended to transform people psychologically, and that ideally all of the arts should work in harmony and unison to this end. For them, a "total art" referred to the idea that all of the arts combined to change the urban environment. As already discussed, the manifestos that spread the early ideas of Modernism often emphasized the need to incorporate art and design into everyday life. This came at a time when people's lives had changed dramatically; at the end of World War I, the notion of constructing Utopian societies offered a way to move beyond the political and social upheaval of the day. To achieve this, it was thought important to bring the ideas and forms of the new art, architecture, and design directly into people's lives.

Oskar Schlemmer
THE TRIADIC BALLET, THE DIVER
YELLOW SERIES
FIGURINE WITH MASK, 1922/1985
Papier-mâché, glass, fabric,
fiberglass, and wood on stainless
steel armature
The Oskar Schlemmer Theatre
Estate, Collection C. Raman
Schlemmer

Oskar Schlemmer
THE TRIADIC BALLET, DISK DANCER
BLACK SERIES
FIGURINE WITH MASK, 1922/1967
Papier mâché, fiberglass, and wood
on stainless steel armature
The Oskar Schlemmer Theatre
Estate, Collection C. Raman
Schlemmer

As early as 1912, Schlemmer began
work on *The Triadic Ballet*—a
project that was not realized until
1922, after he joined the Bauhaus
as director of theater activities.
The elaborate, highly constructed,
and brightly colored costumes
were the most important part of
Schlemmer's plotless ballet. The
motion permitted by their stylized
geometries defined the dancers'
movements. The "Diver," whose feet
were the only body parts able to
move freely, traced floor patterns
and circles in an uncertain motion,
while the two male "Disk" dancers
engaged in energetic walking and
running. Due to their stylized
appearance and movements, the
performers seemed to behave like
marionettes.

Designer unknown
UNTITLED, c. 1920
Letterpress on paper
Merrill C. Berman Collection

In 1917, the Russian Revolution had established the first worker-controlled state in modern Europe. To many at the time, it was a symbol for the transformation of society, and Russian avant-garde artists were prominent in promoting the new vision of a Communist Utopia. Vladimir Tatlin's *Model for a Monument to the Third International*, of 1920 (also discussed in Chapter 3), suggests the integration of art into everyday life. Its spiral structure, open-frame construction, and rotating glass shapes were progressive in both form and function. Tatlin intended his iron and glass tower of 1,300-plus feet to house the Third Communist International, or Comintern—and to symbolically project the spirit of the revolution skyward.

Designer unknown
UNTITLED, c. 1920
Letterpress on paper
Merrill C. Berman Collection

Lyubov Popova
COSTUME DESIGN FOR
ACTOR NO. 7 FOR THE
MAGNANIMOUS CUCKOLD,
1921
Pencil, gouache, and
cut paper
Merrill C. Berman Collection

Alexander Rodchenko
PRODUCTION CLOTHING,
1922
Woven wool, leather trim
V&A: T.40:1, 2–2005
This two-piece suit was
designed by Rodchenko for
his own use, and was
made by his wife Varvara
Stepanova. As part of a
larger trend of self-
fashioning by artists, this
stiff gray wool outfit
enabled Rodchenko to
identify with the factory
worker. By the very clothes
he wore, he invoked both
the technologically
progressive Modernist
agenda and the collective
nature of Soviet society.

Constructivism—A Social Art

Tatlin was joined by young artists including
Varvara Stepanova, Alexander Rodchenko, and
brothers Naum Gabo and Antoine Pevsner, all of
whom emphasized the use of technology to bring
together different art forms. Together, they
declared an end to pure art in favor of a social art
that could be used to help construct a new
society. Termed Constructivism, their work
incorporated sculptural objects that implied
space through intersecting shapes and planes,
rather than solid forms, as well as industrial and
graphic design, engineering, clothing design, and
interior design.

Constructivist art was centered in Moscow at VKhUTEMAS—a Russian acronym for the "Higher State Artistic and Technical Workshops." Led by Nikolai Ladovsky at VKhUTEMAS, designers worked on visionary architectural projects that linked technology and functionalism. Ladovsky's design for a communal house brought together all artistic media to envision the construction of a Communist Utopia. His Association of New Architects also included El Lissitzky, Konstantin Melnikov, Vladimir Krinsky, and Nikolai Dokuchaev.

Nikolai Ladovsky
THE ARCHITECTURAL PHENOMENON OF THE COMMUNAL HOUSE, 1920
Pencil, colored pencil, and colored ink on tracing paper, mounted on paper
Schusev State Museum of Architecture, Moscow

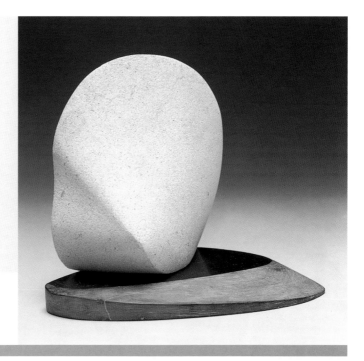

International Constructivism vs. Productivism
Gabo and Pevsner later split from Tatlin over the meaning of "pure" art and issued the Realistic Manifesto. This states that "Only life and its laws are authentic." Their ideas were termed International Constructivism, as opposed to the Productivist art of Tatlin and Rodchenko.

Naum Gabo
STONE WITH COLLAR, c. 1933
Portland stone and slate
Tate, London (TO2147)

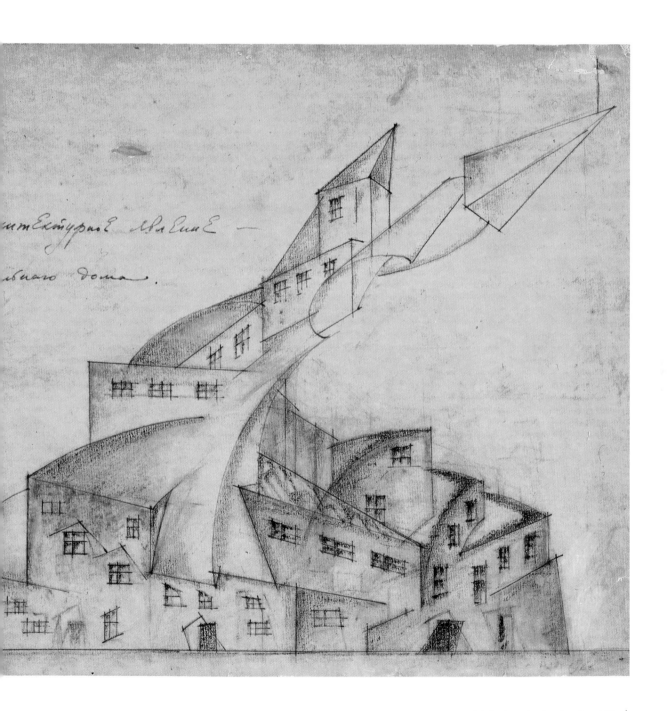

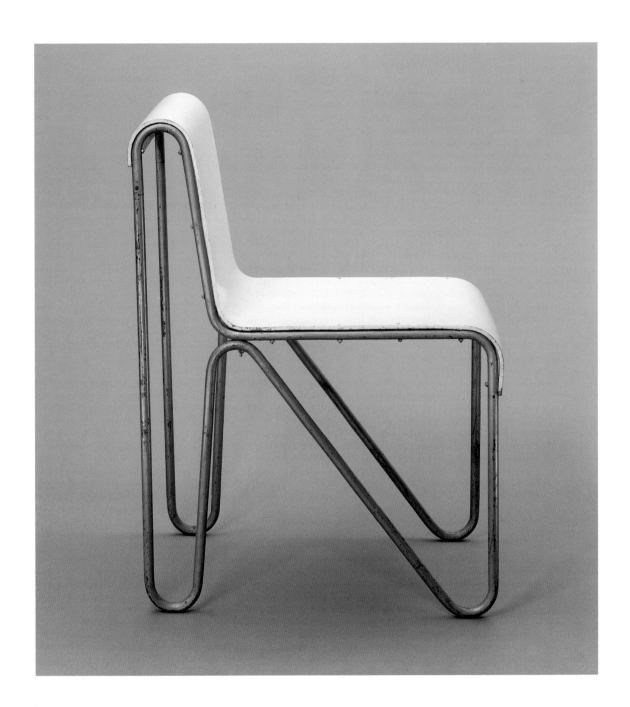

Total Art in the Netherlands and the USSR

Artists associated with De Stijl in the Netherlands also worked to harmonize all the arts—including painting, sculpture, architecture, product and furniture design—around a nonobjective, abstract agenda. The spiritually motivated nonobjective abstraction of Piet Mondrian's paintings inspired practitioners such as Theo van Doesburg and Gerrit Rietveld to explore a geometric foundation for social understanding. The complex ideas relating to abstraction and its various connections to social programs were pioneered by Malevich, Tatlin, Lissitzky, Gabo, Mondrian, van Doesburg, and J.J.P. Oud. Their art was shown throughout Europe in the early 1920s. These works and ideas then coalesced under the rubric of Constructivism. As van Doesburg wrote in his 1923 essay "Towards Collective Construction":

We must understand that art and life are no longer separate domains. The idea that art is an illusion divorced from real life must therefore be abandoned. We demand that it be replaced by the construction of our environment according to creative laws derived from well-defined principles.

RIGHT: J.J.P. Oud
GISO 404 PIANO LAMP,
c. 1928
Lacquered patinated brass
The Metropolitan Museum of Art, New York, Purchase, Charina Foundation Inc. Gift, 2002 (2002.16)
Oud's Giso lamp is as much an abstract sculpture as it is a functional object. Designed for an upright piano, the large lightbulb-containing cylinder is dramatically cantilevered into space, counterbalanced by the heavy brass sphere on the opposite end. The lamp was originally designed as a wedding gift for a friend, but was later put into large-scale production.

LEFT: Gerrit Rietveld
BOW CHAIR 1, 1927
White-painted plywood on painted tubular steel
V&A: W.14–2005, purchased with funds provided by the Horace W. Goldsmith Foundation

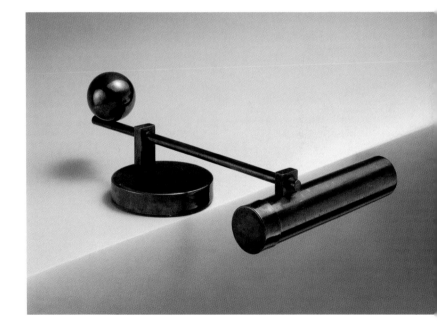

A Machine Aesthetic

In the 1920s and 1930s, in the aftermath of the horrific "war to end all wars," much Modernist art was inspired by the idea of art and life coming together to form a better, Utopian society.

A persistent element connecting artists to the realities of everyday life was the industrialization of the landscape—and the prevalence of a machine aesthetic that linked design to the workers' worlds. This inspired Walter Gropius's multidisciplinary program at the Bauhaus, and Moholy-Nagy's "New Vision" of an art based around photography, film, and graphic design that could dynamically transform the way people related to the world. Gropius believed that the innate design of an industrial object, building, or home could directly affect community and city planning. He later wrote:

My idea of the architect as the coordinator— whose business is to unify the various formal, technical, social, and economic problems that arise in connection with the building—inevitably led me on, step by step, from study of the function of the house to that of the street; from the street to the town; and finally to the still vaster implications of regional and national planning.

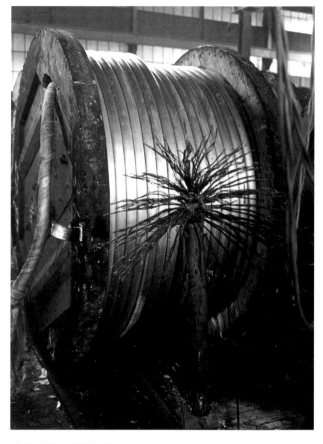

ABOVE: Piet Zwart
UNTITLED (CABLE SPOOL), 1930s
Gelatin silver print
Corcoran Gallery of Art, Washington, D.C., gift of Mr. Joshua P. Smith, 1984.23.11

Kurt Schmidt
MAN AT THE CONTROL PANEL (SCENE DESIGN), 1924
Tempera, ink, and metallic paint
Bauhaus-Archiv Berlin
(BHA 3893)

RIGHT: László Moholy-Nagy
LIGHTPLAY: BLACK/WHITE/GRAY, 1930
Gelatin silver print
The Museum of Modern Art, New York, gift of the photographer
(295.1937)

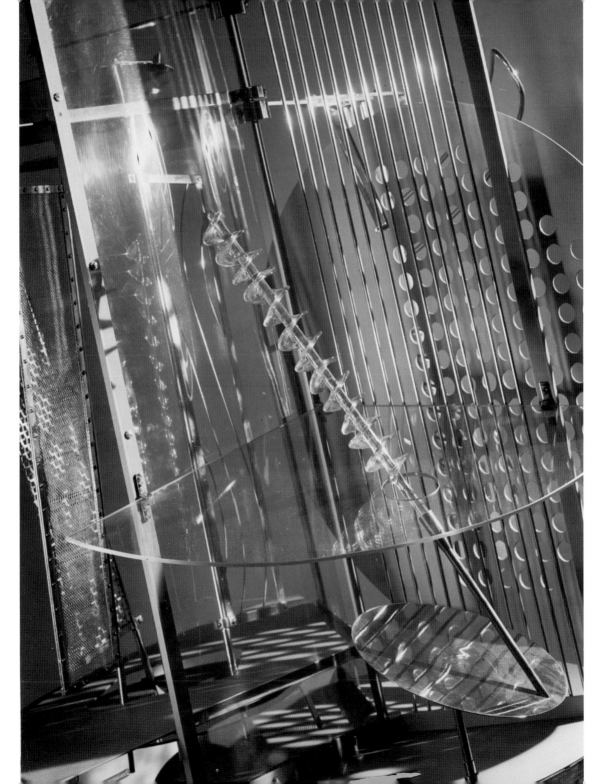

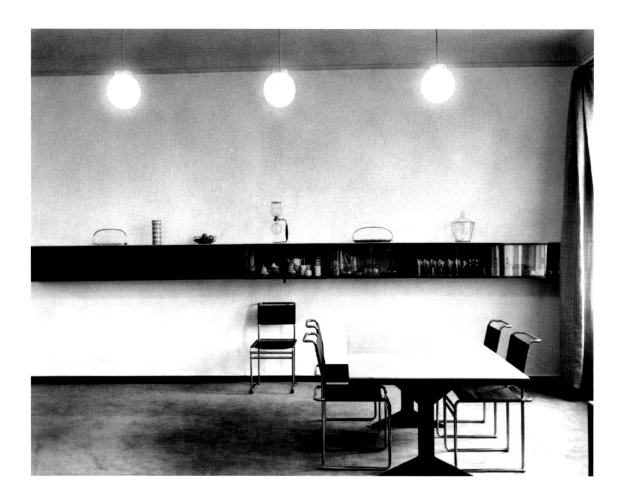

ABOVE: Marcel Breuer
DINING ROOM OF THE
PISCATOR APARTMENT,
BERLIN, 1927
Photograph by Sasha Stone
Ullstein Bild

RIGHT: Grete Lihotzky (Margarete Schütte-Lihotzky)
FRANKFURT KITCHEN (FROM THE AM HÖHENBLICK HOUSING ESTATE,
GINNHEIM, FRANKFURT), 1926–1927
Various materials
V&A: W.15–2005
Installed in more than 10,000 Frankfurt homes, this early Modernist fitted
kitchen was the most successful and influential of its type. Based on detailed
time-motion studies, it was built according to Fordist and Taylorist principles—
designed to minimize wasted space, movement, time, and cost, and to
maximize the comfort and efficiency of the domestic worker. Although Lihotzky
aimed to emancipate housewives through modern scientific principles, in
practice many kitchen laborers became isolated from the rest of the household
due to the small, restrictive space.

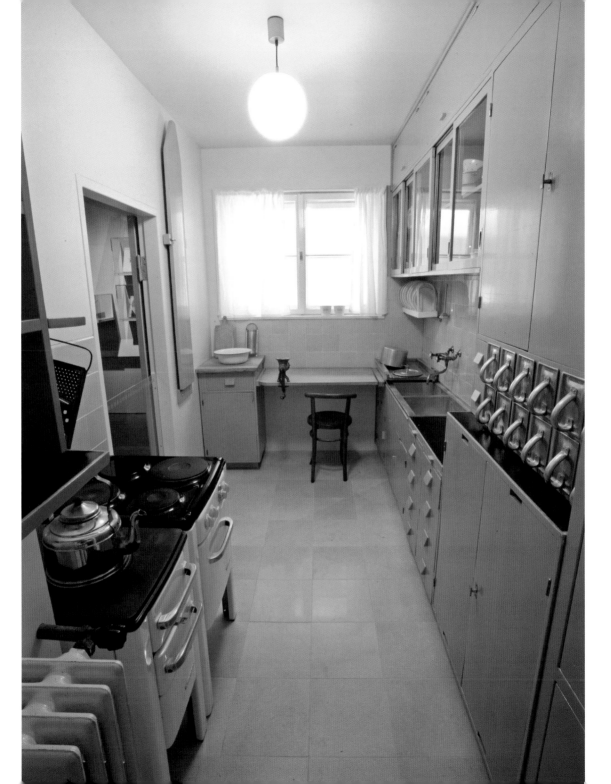

7

AMERICA

Stuart Davis
STUDY FOR SWING
LANDSCAPE, 1937–1938
Oil on canvas
Corcoran Gallery of Art,
Washington, D.C., Museum
Purchase and exchange
through a gift given in
memory of Edith Gregor
Halpert by the Halpert
Foundation and the William
A. Clark Fund, 1981.122
With its lyrical play
between abstraction and
figuration, Davis's tableau is
a quintessentially American
take on Modernism. Davis
drew inspiration from city
life and jazz, placing forms
that appear to reference
industry and construction
into a colorful, rhythmic
dance across the canvas.

On February 17, 1913, America was awakened by
the twentieth-century explosion of modern art.
The occasion was the opening of the International
Exhibition of Modern Art in New York City's
69th Regiment Armory, hosted by the American
Association of Painters and Sculptors. Known as
the "Armory Show," this radical exhibition
featured the work of more than 300 innovative
European and American artists, many of whom
were pushing the boundaries of artistic
convention. The show introduced American artists
and critics to Post-Impressionism, Fauvism,
Cubism—even the early experiments of Marcel
Duchamp and his brother Jacques Villon—and
sparked debates about the new dynamic
direction of art and design.

While the Armory Show was the largest exhibition of modern art in the United States at the time, it was not the first. Alfred Stieglitz had previously exhibited modern European and American painting, sculpture, and post-1908 photography in his New York gallery 291. Exhibits included works by Paul Cézanne, Auguste Rodin, Pablo Picasso, Henri Matisse, Francis Picabia, Marsden Hartley, and John Marin. In 1917, Stieglitz first showed and defended Duchamp's *Fountain*—a found, machine-made urinal, which the Dada artist had controversially declared to be a work of art. Stieglitz also championed American photographers such as Edward Steichen, Paul Strand, and Charles Sheeler: artists who had experimented with urban and industrial subjects, and who pushed their work beyond the pictorial concerns of their predecessors.

In 1920, Duchamp, the artist and patron Katherine Dreier, and the photographer Man Ray formed the Société Anonyme. This was a loose-knit group of artists that organized exhibitions, publications, and public programs. The group also developed one of the most noteworthy collections of modern art in the United States. This kind of involvement between artists and collectors created significant dialogues around issues of Modernism, helping to spark a climate of intense experimentation, which went on to challenge traditional practices throughout the 1920s. Other important collections of Modernist art in the United States included those built by Walter Arensberg, A.E. Gallatin, Duncan Phillips, and The Museum of Modern Art in New York City. This museum opened in 1929, in effect as America's first Modernist museum—focusing on twentieth-century art, photography, film, architecture, and design.

Modernism Spreads through America

After World War I, industrial mechanization and commercial expansion dramatically changed the American landscape. Massive skyscrapers and factories grew and multiplied, dominating a seemingly once-limitless horizon.

As in Europe, this new environment produced a strong effect on the arts. The clean and precise forms of the machine led some American artists, photographers, and designers to champion themes of industrialization, technology, and innovation.

Charles Sheeler
RIVER ROUGE PLANT, 1932
Oil on canvas
Whitney Museum of
American Art, New York
Purchase

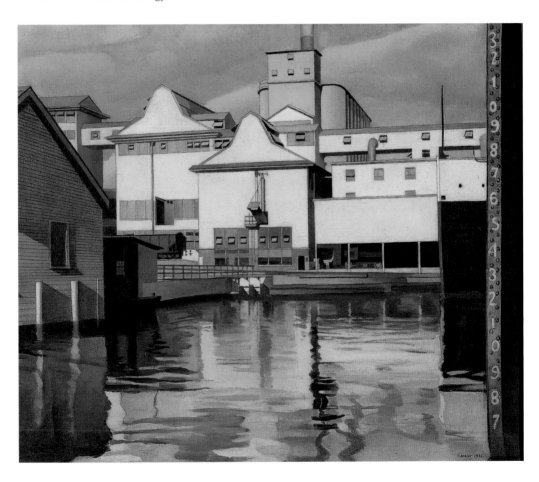

Precisionism

Inspired by Cubism, Purism, and the machine aesthetic of European Dada, a number of U.S. artists developed a distinctly American mix of abstraction and realism, which came to be known as Precisionism. Leaders of the movement included Morton Schamburg, Charles Sheeler, Charles Demuth, Georgia O'Keeffe, Joseph Stella, Ralston Crawford, and John Storrs.

The subjects of Precisionism were concentrated on factories, railroads, and bridges in America's cities, as well as on the smokestacks, grain silos, and water towers that sprouted up across the plains.

Patrick Henry Bruce
PEINTURE/NATURE MORTE,
c. 1925–1926
Oil on canvas
Corcoran Gallery of Art, Washington, D.C., Museum Purchase, Gallery Fund, 68.2
Peinture/Nature Morte is one of a series of at least twenty-five carefully composed tabletop still-lifes painted by the American artist Bruce during his lengthy expatriation in France. Bruce worked on these paintings from 1917 to 1930 in a continuous process of refinement: reducing his complex compositions of everyday objects to their most basic geometries. In his embrace of unmodulated color and simplified architectonic forms, he brought a distinctively modern approach to the traditional genre of still-life painting.

Modernism and the New Deal

During the Great Depression of the 1930s, the Roosevelt administration enacted New Deal programs to create jobs for the mass of unemployed. As part of this initiative, the government created the Works Progress Administration (WPA). The WPA's Federal Art Project hired more than 5,300 visual artists and designers. Their jobs were to create graphics for posters and publications, to create art for public spaces and exhibitions, to teach art in community settings, and to document WPA programs. The wide public dissemination of this work provided an unrivalled forum for broadcasting the emerging Modernist aesthetic throughout America. Artists employed by the Federal Art Project include Jackson Pollock, Adolph Gottlieb, Philip Guston, Jacob Lawrence, and William Baziotes.

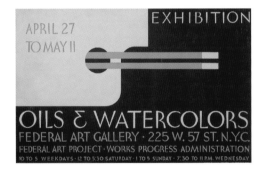

Richard Floethe
EXHIBITION: OILS AND WATERCOLORS, FEDERAL ART PROJECT, c. 1936
Silkscreen
Merrill C. Berman Collection

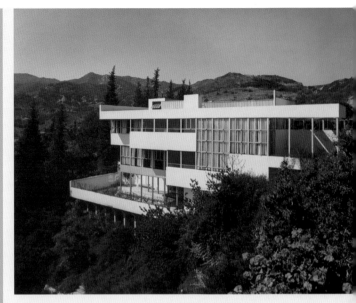

Richard Neutra
LOVELL "HEALTH" HOUSE, LOS ANGELES, CALIFORNIA, 1929
Photo: Julius Shulman, 1950
Gelatin silver print

Perched high up in a ravine in the Hollywood Hills, the Lovell Health House was commissioned by Philip and Leah Lovell, "naturopaths" whose lifestyle centered on exercise and healthy living. Neutra incorporated both the California landscape and the spirit of their pursuits into the design of the house, which included a swimming pool, a gym area in the garden, outdoor sleeping porches, and a kitchen for cooking vegetarian meals. The house also employs steel-frame construction, which allows for large windows, and it contains terraced gardens that spread into the hills and overflow with plant life.

American Modernist Architecture: Wright and the Europeans

American architect Frank Lloyd Wright's work was influential in Europe as early as 1906, when the work of architects in Holland and Germany clearly revealed his influence. His early buildings demonstrated close, sometimes romantic links between architecture and nature, and between craft and modern design. This inspired Viennese architects Rudolf Schindler and Richard Neutra to work with Wright in the United States. Later, by incorporating elements of International Style geometry and open-plan design in the dramatic landscape of California, they helped define the structural transparency and simplicity of American Modernist architecture.

Wright completed some of his most sophisticated designs in the mid-1930s—homes and buildings such as Fallingwater (1935–1937) and the Johnson Wax Building (1936–1939). Also in the 1930s, several major pioneers of International Style architecture, including Walter Gropius, Marcel Breuer, and Ludwig Mies van der Rohe, fled Nazi Germany to arrive in the United States.

Gropius and Breuer taught at Harvard University in Cambridge, Massachusetts. Mies taught at the Illinois Institute of Technology in Chicago, where Moholy-Nagy had also relocated to found the New Bauhaus and the School of Design. The impact of their mature practice grew during the late 1930s and 1940s as they created major works throughout the country, deeply influencing American architecture and visual arts.

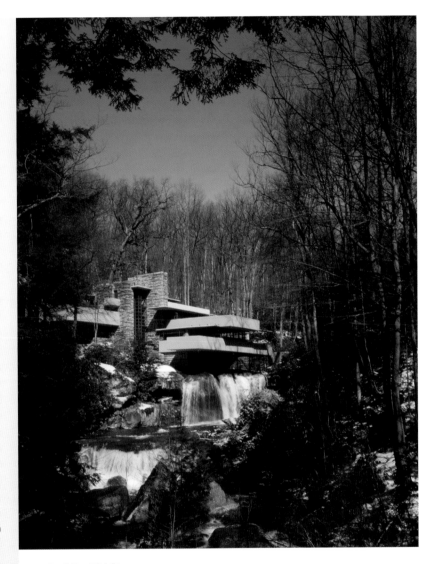

Frank Lloyd Wright
FALLINGWATER, MILL RUN, PENNSYLVANIA, 1935–1937

Fallingwater, the house that Wright designed for the Edgar J. Kaufmann family of Pittsburgh, exemplifies the architect's merging of organic ideals with Modernism. The house is built into a solid rock face and on top of an active waterfall, which can be heard in every room. While the structure is fused intimately with its location in this way, the geometries of its long, cantilevered platforms set the house apart from its environment and reference the International Style.

THE END OF MODERNISM?

György Kepes
PHOTOGRAM (YELLOW AND
WHITE CIRCLES), 1939
Gelatin silver print with
gouache
Corcoran Gallery of Art,
Washington, D.C., Museum
Purchase with Funds from
the Women's Committee

Modernism contains the most influential group of art and design movements of the twentieth century, and its impact can still be found throughout the contemporary world. However, almost since their inception, modern art and design have faced criticism, as well as social and political obstacles.

Modernism and the Rise of the Authoritarian State

The ambiguous, sometimes subversive qualities associated with Modernist art, design, and architecture were always likely to cut against the grain of authoritarian political regimes. Utopia did not enjoy universal appeal. During the 1930s, artists in the Soviet Union and Germany were severely persecuted for producing experimental, forward-looking work that changed the course of twentieth-century art and design.

In Stalin's Soviet Union, Socialist Realism—which presented idealized depictions of peasants and workers—became an official policy. In 1932, abstraction and avant-garde art were effectively banned by a ruling known as "On the Reconstruction of Literary and Art Organizations." All visual arts, cinema, music, and writing had to conform to strict realist guidelines, and were required to serve as propaganda for the state. Some avant-garde artists changed their style or simply stopped working. Others, such as Rodchenko, became isolated at the margins of Soviet culture.

In Germany, following Hitler's 1933 rise to power, the Nazi party created its own propaganda machine and declared many forms of Modernist style to be "degenerate." Of course some right-wing political groups had opposed the Bauhaus during the 1920s, believing it to be a front for Communists. Under Hitler, however, it became impossible for the innovative art school to function at all: the Bauhaus was closed by the Nazi regime on April 11, 1933.

Renato Giuseppe Bertelli
CONTINUOUS PROFILE OF IL DUCE, 1933
Terracotta with black glaze
Imperial War Museum,
London (IWM ART LD 5975)

László Moholy-Nagy
UNTITLED, c. 1940
Gelatin silver print
Art Institute of Chicago,
Gift of George and
Ruth Barford

A Less Doctrinaire Modernism in a Wider World

Europe's loss proved to be America's gain. During the 1930s and early 1940s, many of the innovators of Modernism fled Europe to seek refuge and artistic freedom in America. Mondrian, Duchamp, Léger, and the photographer André Kertész all came to New York during this time. All had a pronounced impact on American art.

László Moholy-Nagy, having first moved to London in 1935, arrived in Chicago in 1937 to become the first director of the influential New Bauhaus, often called the Chicago Bauhaus, an art and design school established by the Association of Art and Industries. Due to funding problems it closed within its first year, but Moholy-Nagy moved quickly. He found support to open the School of Design in 1939, and it subsequently became the Institute of Design. The faculty included Moholy-Nagy's assistant György Kepes. The Institute's innovative, experimental curriculum emphasized photography, light, and technology. It had a profound impact on its many celebrated students, including Arthur Siegel, Nathan Lerner, and Harry Callahan, as well as on the broader course of American photography.

Ludwig Mies van der Rohe came to America in 1937, where he headed the architecture school at the Illinois Institute of Technology in Chicago. Walter Gropius and Marcel Breuer taught at Harvard University. Through this America-based diaspora, Modernism has continued to have a profound influence on international art and design. But it would be true to say that, following the great modern achievements of the interwar period, the style's theoretical emphasis had fallen away, its edge had become dulled.

Or perhaps Modernism had simply become mainstream.

Mainstream Modernism Household implements and furnishings, office buildings and fittings, urban planning, graphic designs, clothing: Modernism is everywhere.

A glass curtain stairwell on the front of a new airport parking garage recalls an early example of the International Style—the revolutionary façade of the model factory and office building designed by Walter Gropius and Adolf Meyer for the Cologne Werkbund exhibition of 1914.

The contemporary graphic design of a new corporate annual report or magazine evokes Alexander Rodchenko's posters of the late 1920s.

Contemporary glass, ceramic, and metal wares recall the designs of Wilhelm Wagenfeld, Hermann Gretsch, Ladislav Sutnar, and Marianne Brandt.

Joseph Binder
NEW YORK WORLD'S FAIR, 1939
Lithograph on paper
Merrill C. Berman Collection

In any event, the last quarter of the twentieth century witnessed the final decline of Modernism. Ironically, the 1970s was a period in which some of the most uncompromising Modernist housing projects were built, and some of the most minimal Modernist-inspired objects were designed. But it was also a period in which the Modernist agenda was widely rejected, as Postmodern artists and thinkers critiqued modern aspirations to universality and aesthetic purity.

Yet the legacy of Modernism remains, seen in a widespread acceptance of the integration of art and life, stress on the unity of all the arts, and the insistence on the role of art in creating new models for living. These have given us profoundly new ways of looking at the world, while paving the way for the many experiments that followed on from the Modernist heyday.

Contemporary art, architecture, and design: all continue to be strongly influenced by the Utopian dreams of Modernist artists. Postmodernism notwithstanding, it is possible that the Modernist experiment itself is still in progress.

Russel Wright
COFFEE URN, c. 1935
Spun aluminum, walnut
The Brooklyn Museum, gift of Paul F. Walter (1944.165.1a–d)
Wright's tableware is perhaps the best example of avant-garde Modernist principles being adapted and realized in consumer design. His early Informal Serving Accessories, of which this coffee urn is a part, consist of rounded biomorphic designs, handmade using spun aluminum and wood. In later years, Russel Wright and his wife Mary would design and market their popular line of colorful ceramic American Modern tableware.

TIMELINE

Artistic Movements

ARTS AND CRAFTS, 1888–1930

ART NOUVEAU, 1890–1914

CUBISM, 1907–1920s

FUTURISM, 1909–1930

SUPREMATISM, 1913–1925

CONSTRUCTIVISM, 1913–1940

DADA, 1914–1922

Key Works of Art and Design

1900s

1910s

1913	Pablo Picasso, *Un verre sur une table (A Glass on a Table)*
1913	Kasimir Malevich, *Black Square*
1914	Marsden Hartley, *Portrait of a German Officer*
1917	Marcel Duchamp, *Fountain*
1918/1923	Gerrit Rietveld, *Red Blue Chair*

1920s

1920	Fernand Léger, *The Mechanic*
1920	Vladimir Tatlin, *Monument to the Third International*
1921	Ludwig Mies van der Rohe, *Friedrichstrasse Skyscraper Project*
1922–1925	Piet Mondrian, *Tableau No. III 1922–1925 with Red, Black, Yellow, Blue and Grey*
1922	Man Ray, *Rayograph*
1923	Nikolai Suetin, *Teacup and Saucer*
1925	Marcel Breuer, *Club Chair*
1926	Coco Chanel, *"Little Black Dress"*
1926	Walter Gropius, *Bauhaus, Dessau*
1926–1927	Grete Lihotzky, *Frankfurt Kitchen*
1926–1927	Fritz Lang, *Metropolis*
1928	Le Corbusier, *Villa Savoye, Poissy, France*
1929	Richard Neutra, *Lovell "Health" House, Los Angeles, California*

1930s

1931	*Empire State Building, New York*
1932	Charles Sheeler, *Industry*
1933	Henry C. (Harry) Beck, *London Underground Map*
1935	Russel Wright, *Coffee Urn*
1936	Alvar Aalto, *Savoy Vase*
1936	Charlie Chaplin, *Modern Times*
1936–1939	Frank Lloyd Wright, *Fallingwater, Mill Run, Pennsylvania*
1937	Hans Ledwinka, *Tatra T87 Saloon Car*

1940s

Politics, Culture, and History

Artistic Movements

1900s

1910s

1913 Armory Show, New York City
1914 Assassination of Archduke Ferdinand, catalyst for World War I
(U.S. enters the war in 1917; war ends in 1918)
1915 San Francisco World's Fair: *Panama-Pacific International Exposition*
1917 Bolshevik October Revolution in Russia
1918–1920 Global flu pandemic, 22 million die
1919 Bauhaus founded by Walter Gropius

1920 American women gain the right to vote
1922 Soviet states form the USSR
1922 James Joyce, *Ulysses*
1925 Paris World's Fair: *Exposition internationale des arts décoratifs et
industriels modernes*
1925 F. Scott Fitzgerald, *The Great Gatsby*
1927 Charles Lindbergh flies across the Atlantic
1928 First scheduled TV broadcasts occur in New York City
1928 Alexander Fleming discovers penicillin
1929 U.S. stock market collapses and triggers the Great Depression
1929 The Museum of Modern Art opens in New York
1929 Barcelona World's Fair: *Spain International Exposition*

1920s

1930 Stockholm World's Fair
1932 Aldous Huxley, *Brave New World*
1933 Adolf Hitler assumes power in Germany, first concentration
camp opens in Dachau
1933 FDR becomes U.S. President, introduces the "New Deal"
1937 Paris World's Fair: *Exposition internationale des arts et techniques
dans la vie moderne*
1939 New York World's Fair, exhibits include "The World of Tomorrow"

1930s

1939–1945 World War II

1940s
and beyond

DE STIJL, 1916–1931

PURISM, 1917–1933

ART DECO, 1918–1940

BAUHAUS, 1919–1933

PRECISIONISM, 1922–1945

INTERNATIONAL STYLE, 1922–1980

SURREALISM, 1924–1947

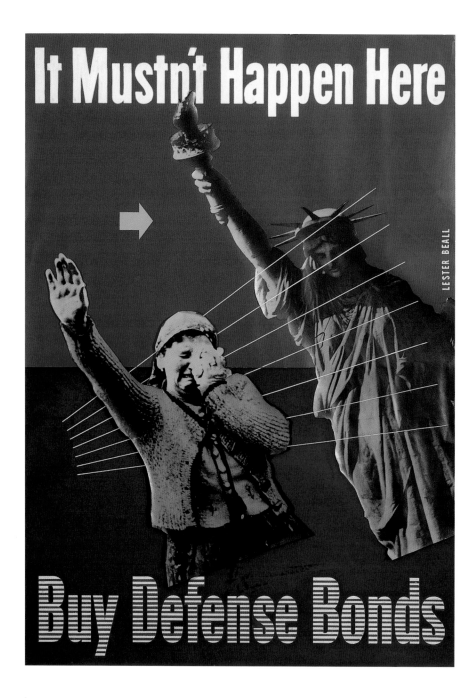

Lester Beall
IT MUSTN'T HAPPEN HERE,
1930s
Gouache and gelatin
silver prints
Merrill C. Berman Collection

Further Reading

Essential Modernism accompanies the exhibition *Modernism: Designing a New World 1914–1939* at the Corcoran Gallery of Art, Washington D.C. The major catalogue of this exhibition, titled *Modernism: Designing a New World 1914–1939* and edited by Christopher Wilk, has been an invaluable resource in preparing the text for *Essential Modernism*.

Albrecht, Donald, Schonfeld, Robert, and Stamm Shapiro, Lindsay, *Russel Wright: Creating American Lifestyle* (exh. cat., Cooper Hewitt Museum, New York, 2001)

Andrews, Richard et al., *Art into Life: Russian Constructivism, 1914–1932* (exh. cat., Hayward Gallery, London, 1996)

Banham, Reyner, *Theory and Design in the First Machine Age* (London, 1960)

Bann, Stephen, ed., *Traditions of Constructivism* (London, 1974)

Benson, Timothy O., *Central European Avant-Gardes: Exchange and Transformation, 1910–1930* (exh. cat., Los Angeles County Museum of Art, Los Angeles, 2002)

Benton, Tim, *The Modernist Home* (London, 2006)

Benton, Tim, *The Villas of Le Corbusier, 1920–1930* (New Haven, 1987)

Chanzit, Gwen F. and Libeskind, Daniel, *From Bauhaus to Aspen: Herbert Bayer and Modernist Design in America* (London, 1987)

Clark, T.J., *Farewell to an Idea: Episodes from a History of Modernism* (New Haven, 1999)

Conrad, Peter, *Modern Times, Modern Places: Life and Art in the Twentieth Century* (London, 1998)

Droste, Magdalena, *Bauhaus 1913–1933* (Cologne, 1993)

Fiedler, Jeannine, ed., *Photography at the Bauhaus* (London, 1990)

Fiedler, Jeannine, Feierabend, Peter, and Ackermann, Ute, *Bauhaus* (Cologne, 1999)

The Great Utopia: The Russian and Soviet Avant-Garde, 1915–1932 (exh. cat., Solomon R. Guggenheim Museum, New York, 1992)

Green, Christopher, *Cubism and Its Enemies: Modern Movements and Reaction in French Art, 1916–1928* (New Haven and London, 1987)

Greenhalgh, Paul, *The Modern Ideal: The Rise and Collapse of Idealism in the Visual Arts from the Enlightenment to Postmodernism* (London, 2005)

Greenhalgh, Paul, ed., *Modernism in Design* (London, 1990)

Gunning, Tom, *The Films of Fritz Lang: Allegories of Vision and Modernity* (London, 2000)

Henket, Hubert-Jan and Heynen, Hilde, eds., *Back from Utopia: The Challenge of the Modern Movement* (Rotterdam, 2002)

Hight, Eleanor, *Picturing Modernism: Moholy-Nagy and Photography in Weimar Germany* (Cambridge, MA, and London, 1995)

Holtzman, Harry and James, Martin S., ed., *The New Art—The New Life: The Collected Writings of Piet Mondrian* (Cambridge, MA, 1986)

Kaplan, Wendy, *Designing Modernity: The Arts of Reform and Persuasion, 1885–1945* (London, 1995)

Mansbach, Steven A., *Modern Art in Eastern Europe: From the Baltic to the Balkans, ca. 1890–1939* (Cambridge, 1999)

Margolin, Victor, *The Struggle for Utopia: Rodchenko, Lissitzky, Moholy-Nagy, 1917–1946* (Chicago, 1997)

Menin, Sarah and Samuel, Flora, *Nature and Space: Aalto and Le Corbusier* (London, 2003)

Neumeyer, Franz, *The Artless Word: Mies van der Rohe on the Building Art* (Cambridge, MA, 1991)

Pevsner, Nikolaus, *Pioneers of the Modern Movement* (London, 1936)

Troy, Nancy, *Modernism and the Decorative Arts: From Art Nouveau to Le Corbusier* (New Haven and London, 1991)

White, Michael, *De Stijl and Dutch Modernism* (Manchester and New York, 2003)

Wilk, Christopher, ed., *Modernism: Designing a New World 1914–1939* (London, 2006)

Wilson, Richard Guy, Pilgrim, Dianne H., and Tashjian, Dickran, *The Machine Age in America, 1918–1941* (exh. cat., Brooklyn Museum, New York, 1986)

Picture Credits

front cover Photo: National Gallery of Canada, Ottawa © 2007 Artists Rights Society (ARS), New York / ADAGP, Paris

page II © 2007 Board of Trustees, National Gallery of Art, Washington © 2007 Artists Rights Society (ARS), New York / VG Bild-Kunst, Bonn

page V © The Trustees of the British Museum

page VIII Photo: Jim Frank © 2007 Estate of Gustav Klutsis / Artists Rights Society (ARS), New York

page 2 Photo: Rainer Viertlböck © Die Neue Sammlung—State Museum of Applied Arts and Design in the Pinakothek der Moderne, Munich

page 3 top © The Museum of Modern Art, New York / Licensed by Art Resource, NY

page 3 bottom Photo: National Gallery of Canada, Ottawa © 2007 Artists Rights Society (ARS), New York / ADAGP, Paris

page 4 © Roy Export Company Establishment

page 5 top Victoria and Albert Museum, London © Estate of Lester Beall / Licensed by VAGA, New York, NY

page 5 bottom left © V&A Images

page 5 bottom right Corcoran Gallery of Art, Washington, D.C.

page 6 Nederlands Architectuur Instituut, Rotterdam © 2007 Artists Rights Society (ARS), New York / Beeldrecht, Amsterdam

page 7 top, bottom © V&A Images

page 8 © Estate of Alexander Rodchenko / RAO, Moscow / VAGA, New York, NY

page 10 British Film Institute © Janus Films, Inc. & BBC

page 11 top © Rodchenko & Stepanova Archive © 2007 Artists Rights Society (ARS), New York / VG Bild-Kunst, Bonn

page 11 bottom Photo: Jim Frank © 2007 Artists Rights Society (ARS), New York / SIAE, Rome

page 16 © Muzeum Sztuki Lodz

page 17 top © V&A Images

page 17 bottom Photo: Gabriel Urbánek © Ladislav Sutnar, reproduced with the permission of the Ladislav Sutnar Family

page 18 top © The Trustees of the British Museum

page 18 bottom © Sandro Michahelles Fotografo

page 19 top Corcoran Gallery of Art, Washington, D.C. © 2007 Estate of Pablo Picasso / Artists Rights Society (ARS), New York

page 19 bottom Corcoran Gallery of Art, Washington, D.C.

page 20 left Photo: Jim Frank © 2007 Artists Rights Society (ARS), New York / SIAE, Rome

page 20 right Ottavio and Rosita Missoni Collection © 2007 Artists Rights Society (ARS), New York / SIAE, Rome

page 21 top © V&A Images

page 21 bottom Stedelijk Museum Amsterdam © 2007 Artists Rights Society (ARS), New York / Beeldrecht, Amsterdam

page 22 © The Museum of Modern Art, New York / Licensed by Art Resource, NY © 2007 Artists Rights Society (ARS), New York / Beeldrecht, Amsterdam

page 23 left, right Photo: Jim Frank © 2007 Artists Rights Society (ARS), New York / Beeldrecht, Amsterdam

page 24 top Photo: Jim Frank © 2007 Artists Rights Society (ARS), New York / VG Bild-Kunst, Bonn

page 24 bottom © V&A Images

page 25 left Bauhaus-Archiv Berlin

page 25 right Photo: The Art Institute of Chicago © 2007 Artists Rights Society (ARS), New York / VG Bild-Kunst, Bonn

page 26 top © The Museum of Modern Art, New York / Licensed by Art Resource, NY © 2007 Artists Rights Society (ARS), New York / VG Bild-Kunst, Bonn

page 26 bottom Bauhaus-Archiv Berlin

page 27 top Photo: A. Laurenzo © Die Neue Sammlung—State Museum of Applied Arts and Design in the Pinakothek der Moderne, Munich

page 27 bottom left © V&A Images © 2007 Artists Rights Society (ARS), New York / VG Bild-Kunst, Bonn

page 27 bottom right © V&A Images © 2007 Artists Rights Society (ARS), New York / VG Bild-Kunst, Bonn

page 28 top © V&A Images

page 28 bottom © Fondation Le Corbusier

page 29 top Photo: Jim Frank © 2007 Artists Rights Society (ARS), New York / VG Bild-Kunst, Bonn

page 29 bottom The Porcelain Museum, State Hermitage Museum, St. Petersburg

page 30 top © Estate of Alexander Rodchenko / RAO, Moscow / VAGA, New York, NY

page 30 bottom The Bakhrushin State Theatrical Museum, Moscow

page 31 top © Tate, London 2007

page 31 bottom Photograph: Courtesy of The Kreeger Museum, Washington, D.C. © 2007 Artists Rights Society

(ARS), New York / ADAGP, Paris

page 32 © The Museum of Modern Art, New York / Licensed by Art Resource, NY © 2007 Artists Rights Society (ARS), New York / VG Bild-Kunst, Bonn

page 34 © Nederlands Architectuur Instituut, Rotterdam / Collection Van Eesteren-Fluck & Van Lohuizen Foundation, The Hague

page 35 top Digital image: Philip Brookman © Estate of Boris Ignatovich / RAO, Moscow / VAGA, New York, NY

page 35 bottom © V&A Images

page 36 top Bauhaus-Archiv Berlin © 2007 Artists Rights Society (ARS), New York / VG Bild-Kunst, Bonn

page 36 center This image is reproduced with the kind permission of the National Museum of Ireland

page 36 right Photo: Otto Lossen © Fondation Le Corbusier

page 37 Nederlands Architectuur Instituut, Rotterdam

page 38 top Nederlands Architectuur Instituut, Rotterdam © 2007 Artists Rights Society (ARS), New York / Beeldrecht, Amsterdam

page 38 bottom Deutsches Architekturmuseum, Frankfurt-am-Main

page 39 top, bottom © V&A Images

page 40 Photo: Jim Frank

page 42 © The Museum of Modern Art, New York / Licensed by Art Resource, NY © 2007 Man Ray Trust / Artists Rights Society (ARS), New York / ADAGP, Paris

page 43 © 1989 The Metropolitan Museum of Art, New York

page 44 Victoria and Albert Museum, National Art Library © 2007 Artists Rights Society (ARS), New York / VG Bild-Kunst, Bonn

page 45 Corcoran Gallery of Art, Washington, D.C. © 2007 Albert Renger-Patzsch Archiv / Ann u. Jürgen Wilde, Zülpich / Artists Rights Society (ARS), New York

page 46 left Bauhaus-Archiv Berlin © 2007 Artists Rights Society (ARS), New York / VG Bild-Kunst, Bonn

page 46 right © V&A Images © 2007 Estate of Gustav Klutsis / Artists Rights Society (ARS), New York

page 47 left Photo: Jim Frank © 2007 Estate of Gustav Klutsis / Artists Rights Society (ARS), New York

page 47 right Photo: Jim Frank © Estate of Alexander Rodchenko / RAO, Moscow / VAGA, New York, NY

page 49 British Film Institute © 2007 Artists Rights Society (ARS), New York / ADAGP, Paris

pages 50/51 © The Art Institute of Chicago

page 52 Courtesy of Corkin Shopland Gallery, Toronto

pages 54, 55 Photo Archive C. Raman Schlemmer © 2007 Bühnen Archiv Oskar Schlemmer / The Oskar Schlemmer Theatre Estate, 28824 Oggebbio (VB), Italy

page 56 top, bottom Photo: Jim Frank

page 57 top Photo: Jim Frank

page 57 bottom © V&A Images © Estate of Alexander Rodchenko / RAO, Moscow / VAGA, New York, NY

page 58 The works of Naum Gabo © Nina Williams

page 59 Schusev State Museum of Architecture, Moscow

page 60 © V&A Images

page 61 © The Metropolitan Museum of Art

page 62 top Corcoran Gallery of Art, Washington, D.C.

page 62 bottom Bauhaus-Archiv Berlin

page 63 © The Museum of Modern Art, New York / Licensed by Art Resource, NY © 2007 Artists Rights Society (ARS), New York / VG Bild-Kunst, Bonn

page 64 © Ullstein Bild / The Granger Collection, New York

page 65 © V&A Images

page 66 © Estate of Stuart Davis / Licensed by VAGA, New York, NY

page 68 Photo: Moderna Museet / Stockholm © 2007 Artists Rights Society (ARS), New York / ADAGP, Paris / Succession Marcel Duchamp

pages 70/71 Corcoran Gallery of Art, Washington, D.C.

page 72 left Photo: Jim Frank

page 72 right © J. Paul Getty Trust. Used with permission. Julius Shulman Photography Archive, Research Library at the Getty Research Institute

page 73 Robert P. Ruschak, Courtesy of Western Pennsylvania Conservancy

page 74 Courtesy of Alpha Gallery, Boston © Estate of György Kepes

page 76 Imperial War Museum, London © The Artist's Estate

page 77 Photo: The Art Institute of Chicago © 2007 Artists Rights Society (ARS), New York / VG Bild-Kunst, Bonn

page 78 Photo: Jim Frank

page 79 Brooklyn Museum

page 82 Photo: Jim Frank © Estate of Lester Beall / Licensed by VAGA, New York, NY

back cover © Fondation Le Corbusier

Index

Page numbers in *italics* refer to captions.